FULL & SPARE: CERAMICS IN THE 21ST CENTURY

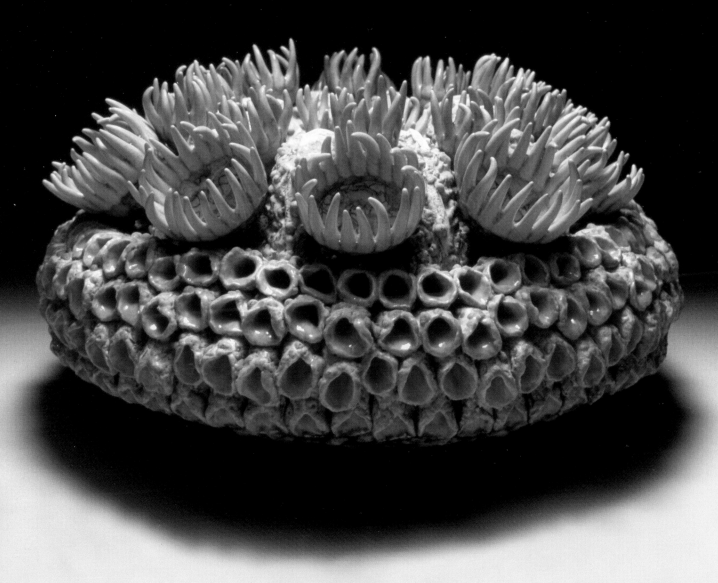

MUSEUM OF FINE ARTS
Seven Days of Opening Nights Festival
February 15 - March 23, 2008

FLORIDA STATE UNIVERSITY
College of Visual Arts, Theatre & Dance

This program was organized by the Florida State University Museum of Fine Arts with grant assistance from the Florida Arts Council of the State of Florida, and the Leon County Cultural Development Program. Educational Programming is supported through the State Partners Grant Initiative of the City of Tallahassee Cultural Services, Council on Culture and Arts.

PROJECT SUPPORT AND ORGANIZATION

FULL & SPARE: Ceramics in the 21st Century was organized by the Florida State University Museum of Fine Arts. Essayist: Kate Bonansinga. Project Staff: Allys Palladino-Craig, Grantwriter / Editor; Stephanie Tessin, Exhibition Registrar / Editorial Assistant; Jean Young, Fiscal Officer; Teri Yoo, IT / Communications Officer; Viki D. Thompson Wylder, Educational Programming; Wayne Vonada, Chief Preparator. For the concept and title of a ceramics exhibition with the parameters of "Full & Spare," the Museum is indebted to Holly Hanessian, Professor of Ceramics at Florida State University.

This program is sponsored in part by:

The State of Florida,
Department of State,
Division of Cultural Affairs,
Florida Arts Council, and the
National Endowment for the Arts;
The City of Tallahassee State Partners
Grant Initiative and the
Leon County Cultural
Development Grant Program,
both administered by the
Council on Culture and Arts.

Cover and facing page: [cover] Digital collage of Holly Hanessian's *Full & Spare* and elements of *Sperm & Eggs* [on the facing page], 2007, porcelain, dimensions variable. Photo credit: Jon Nalon.

Title page: Ying-Yueh Chuang, *Plant-Creature*, 2006, multiple-fired ceramics from cone 6 to cone 06 in oxidation, 30 x 30 x 16 cm. Ms. Chuang's work appears courtesy of the Ontario Arts Council and the Canada Council for the Arts.

Canada Council Conseil des Arts
for the Arts du Canada

ONTARIO ARTS COUNCIL
CONSEIL DES ARTS DE L'ONTARIO

Design: Julienne T. Mason,
JJKLM, Lansing, Michigan
Pre-press Graphics: Daniel McInnis,
Progressive Printing
Printer: Progressive Printing,
Jacksonville, Florida

ACKNOWLEDGEMENTS

The Ceramics Department at Florida State has been taken in hand by new faculty member Holly Hanessian, who will have been in residence just over a year as *Full & Spare* premiers. Always on the lookout for great artwork, Museum curatorial staff were excited to meet a new ceramics artist and subsequently invited her and seventeen others from the continental United States and Canada to participate in this year's *Seven Days of Opening Nights* exhibition. Not having hosted clay sculpture since the seventies, MoFA had some catching up to do. It has been with the greatest of pleasure that we began working with writer Kate Bonansinga of the University of Texas / El Paso, as we prepared *Full & Spare*. To Kate we offer utmost gratitude for her thorough research and her eloquent essay. To our public grant agencies—the Florida Arts Council, the City of Tallahassee, the Leon County Cultural Development Program—the most heartfelt of thanks from our Museum and our audience. And to the *Seven Days* Board, and new Director Steve MacQueen, heartiest congratulations on the Festival's successful first decade.

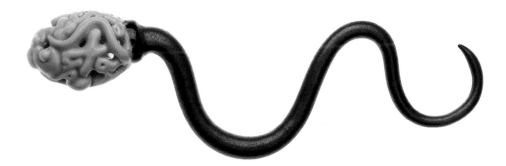

Holly Hanessian has been a whirlwind of enthusiasm since her arrival in January of 2007. She, a colleague and a graduate student visited China this past summer to exhibit work and promote cultural exchange...and that was after only one semester here! An artist involved with text and universal iconography, Hanessian identifies resonant concepts and articulates sculptural equivalents. Every act of language, every communication between one or more individuals, is built upon essential structures of cognition such as *full* and *spare*. As Museum staff evolved the idea of a ceramics exhibition, it was Holly who suggested that this particular artist group was working both *full* and *spare*—either artists have so much to say that their sculptures celebrate and proclaim abundance, riotous color, complicated references, or they proffer a conceptual richness in works that have instead been honed down and pared away to a disciplined but expressive simplicity. The exhibition title is only the beginning, only a place to start enjoying all the variations-upon-theme described so ably by Kate Bonansinga.

The Museum of Fine Arts welcomes all visitors to this splendid event, with special thanks to the artists who loaned their vibrant works and to the many underwriters of an important exhibition.

Allys Palladino-Craig
Director, MoFA

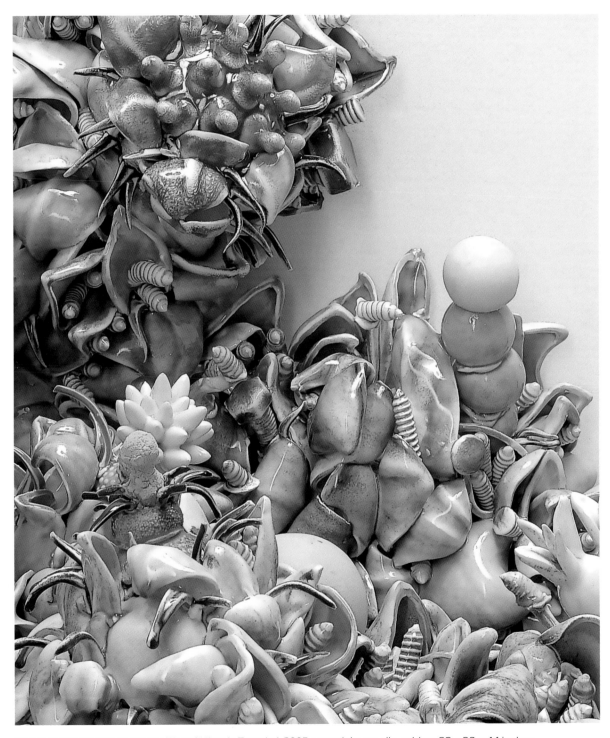

Susan Beiner, Detail of *Rather Than Obliquely Encoded*, 2005, porcelain, acrylic, rubber, 32 x 38 x 44 inches.

NATURE, MANIPULATION AND THE HYBRID: CERAMIC SCULPTURE TODAY

"I define postmodern as the incredulity toward meta-narratives..."[1]
—Jean-François Lyotard

KATE BONANSINGA

If we accept Lyotard's definition, *Full and Spare* is a quintessentially postmodern exhibition. Here, anything goes. The cacophony of the twenty-first century ever increases in direct relationship to enhanced technological capabilities and to population growth. In part, we respond by letting go of any hope of control. On the other hand, it is more tempting than ever to categorize things in order to try to make sense of them. Today, we can apply Cartesian thought, with all of its failings, as one tool to help us to better understand our world.

So, at the risk of being overly reductive, and with the knowledge that organizational systems are inherently flawed and often random, I divide my discussion of the artists exhibited here into three loose and broad categories based on my understanding of their ideas. My intention in doing this is to increase our appreciation for their art and to offer some insight on the fluid state of affairs of ceramic sculpture today. Taking a cue from Lyotard and resisting the meta-narrative, I consider these categories to be mini-narratives. They are three of the many that the exhibition supports. All are on equal footing, and all cross paths.

Nature, Reproduction and the Decorative

The impulse to beautify and decorate is, of course, as old as humanity. But within the confines of the Western canon, the seventeenth-century Baroque is the era that comes immediately to mind as the first to acknowledge the mysterious forces of nature by depicting them as opulent, decorative and theatrical. This was the dawn of the Age of

Reason; the Baroque scientist deemed physical nature as matter in motion through space and time, and the Baroque artist represented this matter in gilded renditions of flora, fauna and flying putti. Pre-dating interior design as a concept, there is evidence that the decorative schemes in Baroque palaces were instrumental to political-power plays. Back then the decorative was laden with meaning.[2]

As it is today. The artists in this exhibition who harness the power of the decorative do so in order to communicate their ideas. Susan Beiner describes her work as "opulent" and credits her interest in Baroque-era porcelains as the seed of her decision to become an artist. Beiner lived in Detroit from 1994-2000 and is familiar with manufacturing environments and their unexpected beauty. In the 1990s she created plaster molds from construction materials, such as rebar and fasteners, cast multiple objects from each mold, and then literally crammed these objects onto vessels. Though the individual elements are industrial, each completed piece emanates the organic, and consequently captures the tension between the manufactured and the natural.

Recently Beiner has departed from the vessel format and is creating compilations of clay elements that look like mounds of flowers, leaves and aquatic life. They hang on the wall and rest on the floor, and create a spatial dynamic between them. The gallery as site is Beiner's playing field and seems to shrink when she introduces one of her sculptures, each of which teems with life and

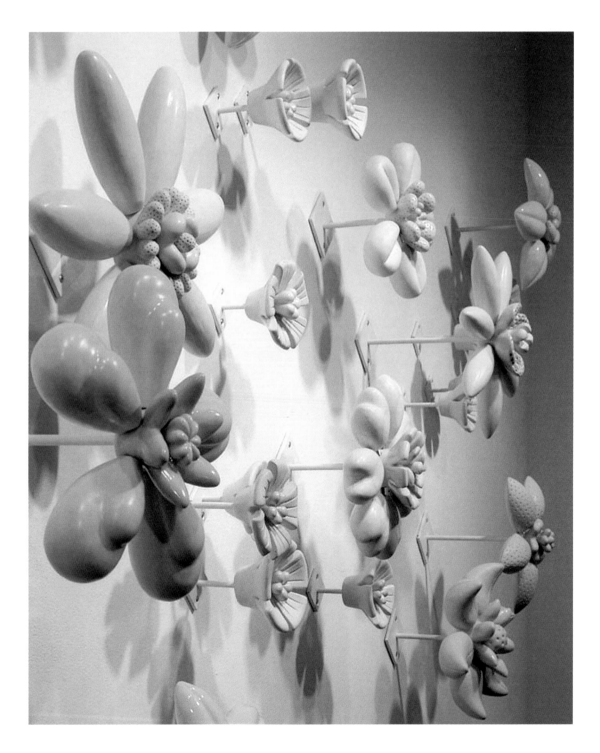

Nancy Blum, Detail of *Flower Wall*, 2000, ceramic, metal, 60 x 172 x 12 inches.

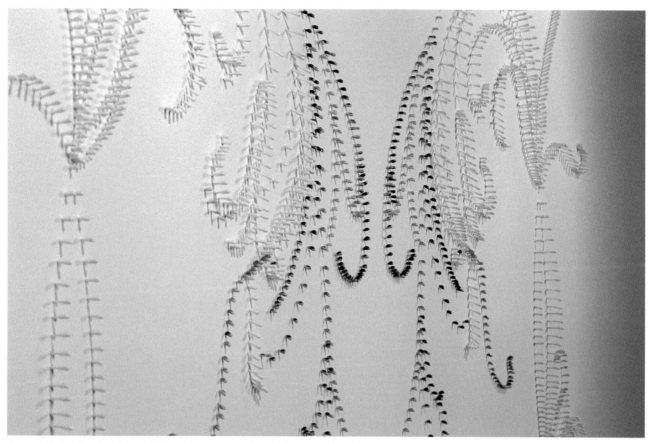

Jeanne Quinn, *Perfect Lover*, 2001, glazed porcelain and Q-tips, 100 x 112 x 1 ½ inches.

information. What begins as a physically additive process evolves into a spatially subtractive one. Her palette is artificially bright: she reverses her earlier trajectory. In her words, she is "making what is organic into synthetic" rather than the other way around. Decorative renditions of natural phenomena define the interior environment, a contemporary take on the Baroque tradition.

Nancy Blum explores the flower as a subject, and pattern as a device, in her sculptures and drawings. For *Flower Wall* she hand-formed oversized, stylized porcelain flowers, all in full bloom and covered in near-white glaze. A metal bracket attaches to the underside of each and then mounts to the wall, so that the top of each flower thrusts forward, towards the viewer. The petals are volumetric, like tiny pillows, and their surfaces are smooth, without details. This, combined with their monochrome palette and their bigger-than-life size (twelve to twenty inches in diameter for the one-of-a-kind elements, slightly smaller for the multiples), make them an industrialized version of their counterpart in nature. They seem to have unprecedented endurance and fortitude.

Like Blum, Jeanne Quinn creates wall-mounted sculpture comprised of repeated forms. As a source of inspiration, Quinn cites *Gesamtkunstwerk* (the complete work) presented by Richard Wager in his 1849 essay *The Artwork of the Future*. In Wagner's era, use and beauty were paramount, the aesthetic was the ideal. The decorative arts engaged many of the senses, especially sight, touch and taste, and had the potential to define domestic space, from furniture, to lighting, to

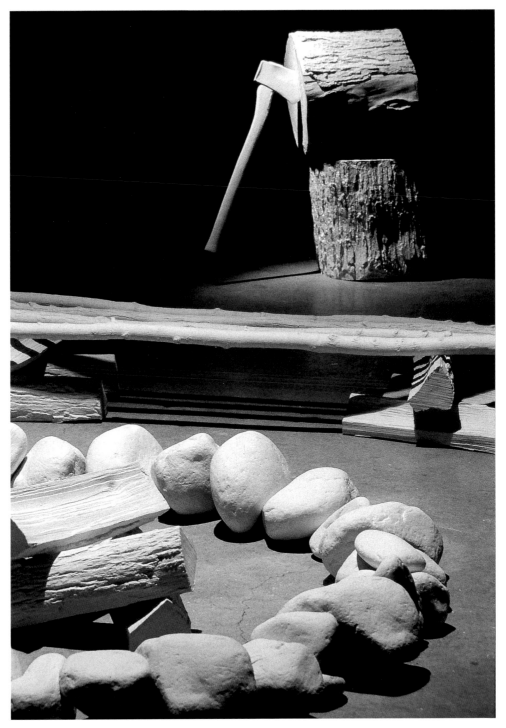

Jeremy Hatch, Detail of Standing Camp, 2003, porcelain, backlit print, dimensions variable.

wallpaper, to carpets, to tableware. Quinn brings that possibility into the twenty-first century and creates sensually encompassing exhibitions, bridging the gap between the decorative arts of over a century ago and today's installation art. In both, the viewer becomes a participant in, and actually enters into, the work of art.

But in order to do this, Quinn engages the mind as well as the body in a postmodern strategy that nineteenth-century ceramists and metal smiths did not have access to. For example, in *Perfect Lover* and *Suspended*, Quinn capitalizes on our associations with domestic uses of cotton swabs; they come into contact with the most intimate parts of our bodies. By combining actual swabs with cast porcelain ones Quinn not only plays upon our perception of the real and the fake, but also stretches our expectations of the materials for drawing, since the swabs and their remakes compose lines; their shadows are actual rather than illusory. Quinn's symmetrical composition is monumental but delicate. Because of its paleness in an initial glance, it can almost be overlooked; its grandness takes hold once it has registered visually. It connects the life of the body to the life of the mind, that which is real to that which is perceived or imagined.

The same might be said of Jeremy Hatch's *Treehouse*, a nearly full-sized, pale porcelain rendition of a rickety tree house in a leafless tree. When considered in the context of *Standing Camp*, another work by Hatch that comments on the logging industry, *Treehouse* might be interpreted as having an environmentalist bent, an homage to trees in general, which are too rapidly disappearing. It is a fragile but lasting memorial with the neutrality of a tombstone.

Yet the illusion achieved by the realism of *Treehouse*'s details invites another interpretation, one that follows social theorist Jean Baudriallard's contention that the media's mimicking of reality cripples the actual.[3] The simulated trumps the real; surrogates become more ordinary than originals. From this perspective, Hatch's strategy is similar to that of artist Roxy Paine, who creates simulations of nature. Paine's *Bluff*, which was installed in New York's Central Park as part of the Whitney Biennial 2002, was a fifty-foot high tree made of reflective stainless steel, and stood unchanging between winter and spring. It was a reminder to passersby that the line between the real and the artificial is increasingly fine, and that city parks are planned constructs, impotent replicas of nature.

Finally, when viewed side-by-side with Hatch's *Swingset*, *Treehouse* initiates memories of the promise, tenderness and pain of childhood. It pulls on the heartstrings without resorting to sentimentality, and this is its most important victory.

Ying-Yueh Chuang also nearly mimics nature, but twists it to create imagined hybrids of aquatic and terrestrial plants. Some are patterned and spherical and look like abstractions of asteroids; others are vessel forms. The artist nods to the history of applied arts, and then lends her "creatures" a futuristic flair. Born in Taiwan and now living in Canada, Chuang combines the delicacy and detail of decorated Asian export porcelains with the exuberance and repetition of bold patterns. Ultimately, Chuang alters forms found in nature ever so slightly and then combines them in imagined ways to create objects that demand a second look before their strangeness is completely digested. When viewed from above, the *Cross* series has the effect of a miniature garden or a detailed rug.

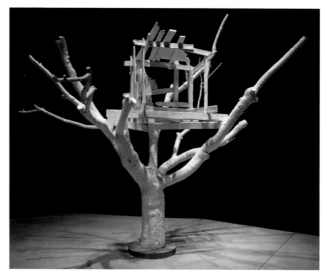

Jeremy Hatch, *Treehouse*, 2006, porcelain, 9 x 12 x 12 feet.

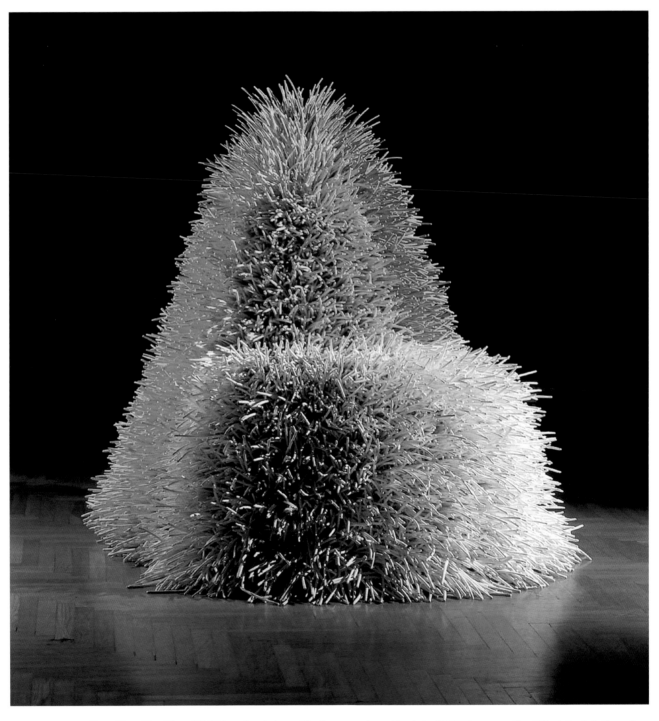

Bean Finneran, *Slow Time/Play Time*, 2005, low fired clay with glazes and acrylic stain, 50,000 curves, 7 x 7 feet. Installation view at Mills College, Oakland, CA. Photo credit: Joe Schopplein.

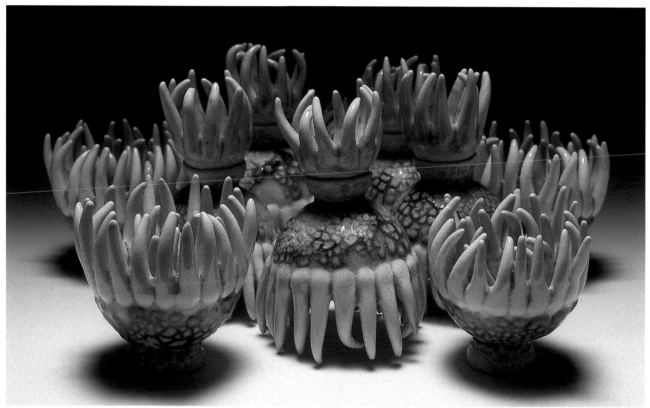

Ying-Yueh Chuang, *Plant-Creature #9*, 2006, multiple-fired ceramics from cone 6 to cone 04, 5 x 5 x 8 cm. each/set of two.

Bean Finneran shares Chuang's interest in sea life and in repeated forms. The artist's residence and studio are situated on the coast of California; seaweed and coral are her muses. The artist hand rolls what she calls "curves," thorn-shaped pieces, thousands and thousands of them, each about eight inches long. She then paints them in acrylic, usually vibrant colors such as red, chartreuse and blue, and stacks them into cone-shaped piles that suggest not only plant life, but also controlled accumulation. The artist states, "We have endless heaps of repeated industrial objects littering the landscape."[4]

Finneran's stacking process is partly intuitive and partly learned. First, she drops a handful of curves on the floor or tabletop. She then adds more, one by one, carefully but quickly inserting them into the pile, like Pick-up sticks in reverse. The curves make a clicking sound as they brush the others and become part of the compilation, so there is a aural component to the process. Even after Finneran determines that the cone is complete, it exudes a potential for change and the possibility of transformation simply because there is no inner armature or support structure and the artwork is not monolithic. Finneran notes that working in multiples allows her to "really occupy a space," and she feels that such works have a site-specificity that connects with the gallery space in a way that other objects don't.[5] For the smaller sculptures, Finneran trusts whoever is displaying the piece to pile the curves and complete it, so there is potential for prescribed participation.

Spatial Manipulation and Intervention

Delightfully out of context, a J.D. Salinger quote appears at the top of Jae Won Lee's studio notes. In Salinger's *Franny and Zooey*, there is a discus-

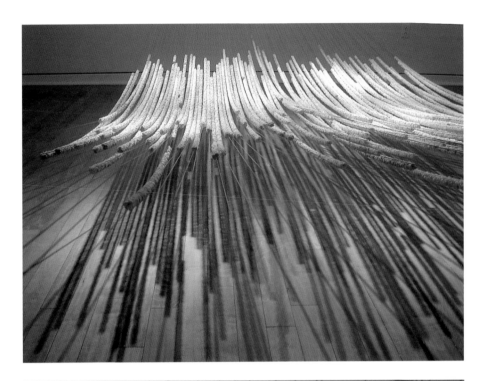

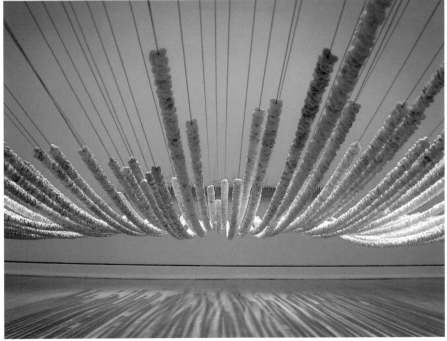

Jae Won Lee, Installation views of *Between the Petals II*, 2006, porcelain, piano tuning block, wire, pins, 40 x 192 x 60 inches. Photo credit: Elizabeth Cryan.

sion of the first halting steps toward believing; beginning with a simple mantra, the process is inevitably fraught with self-doubt and uncertainty. Not until the investment of energy builds and time has elapsed can efforts be justified toward the invocation of deity. Evolution from nothingness to powerful realization is one of the artist's articles of faith (or at least an article of hope) and it proceeds by increments, just as the sculptures by Jae Won Lee do, sculptures which are remarkably reticent and subtle. Lee's works are additive: individual components are massed to command significant spatial dimensions. The revelation for the viewer is of the hand and mind of the maker, of soothing pattern and quiet affirmation. In *Between the Petals II* (2006), gentle tones and delicate textures harmoniously balance against the tension of porcelain on piano wire; yet the gravity of suspension is controlled and graceful. In *Frail Hope, Internal Distance: Object III* (2004), stacked wands of blue and gray and white provide a sense of order from thousands upon thousands of disparate, monofilament-laced porcelains. While the private symbolism of an artist can be bell-like and clear, it can also be an aria sung in a foreign language, needing a libretto for interpretation. Not so of Lee's works: under the spell of her aesthetic, viewers do not require translation.

It has been said of *Ploen-nanofolk*, one of Linda Sormin's sculptures, that it "...is never at rest. Upon completion, the work remains delightfully and uncannily resonant with its becoming."[6] This implied potential for growth and transformation, and the scale and presence of her forms, connects Sormin to Finneran. Sculptors Sarah Sze (b. 1969) and Nancy Rubins (b. 1952) also come to mind as having shared interest in conveying controlled accumulation in sculptures that look like scientific experiments gone wrong. They, like Sormin, have the ability to create chaos and then order it. Sze shares Sormin's penchant for bringing delicate parts together to create a complex, volumetric object that seems massive. And Rubins shares Sormin's commitment to a singular material: found airplane parts for the former and porcelain for the latter.

In Sormin's work there is a survivalist mentality at play, a desperation to maintain some semblance of order and structure in the face of all odds. Creation and destruction cohabit. These structures seem as if they might provide maze-like refuge for tiny beings, with their complex schema of negative spaces, but for humans they confront rather than shelter, and articulate the frenzy of contemporary life.

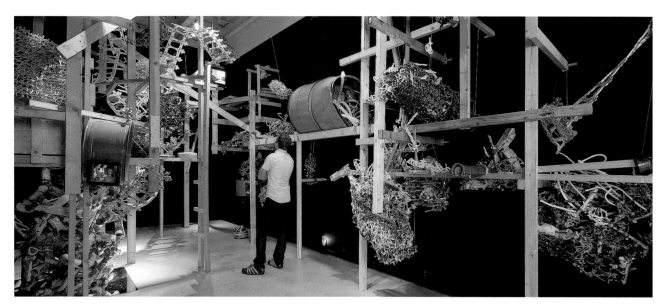

Linda Sormin, View from entrance, *Roaming Tales*, 2007, ceramic and mixed media installation, Surrey Art Gallery TechLab. Photo credit: Scott Massey.

Jeffrey Mongrain, *Cathedra*, 2002, clay, glass, ash, 19 x 11 x 9 inches.

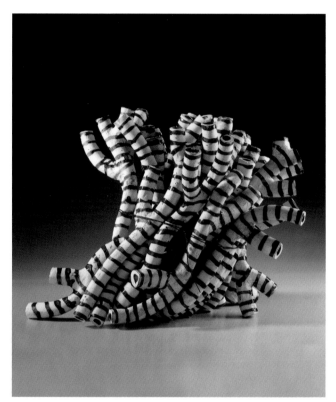

Annabeth Rosen, *Bundle*, 2006, glazed ceramic, 16 x 20 x 16 inches. Collection of Sandra and Gerry Eskin, Chicago.

ed from multiple and delicate threads, is part of a series of pale, abstract forms. Mongrain installed them on and around the dramatic, marble figurative sculptures that comprise a narrative program in a European Baroque-style church. The artist manipulates not only space, but also pre-existing art works and objects, mutating their meanings. The postmodern meets the pre-modern in beautiful yet odd juxtapositions that encourage reflection on the beliefs of each of those eras, where they come together and where they diverge. In another recent series, Mongrain rests a glass sphere on a ceramic form that looks like a pillow, and that hangs perpendicular to the wall. The "pillows" seem to float, defying their own weight, and to have the flexibility of fabric combined with the rigidity and smoothness of porcelain. Mongrain manipulates the material to look like something other than what it is and, in doing so, questions the compatibility of what is known and what is perceived.

Annabeth Rosen has become well known for her thick, fired slabs of clay that seem to ooze with life and to recognize the earth as their place of origin. Rosen usually combines several slabs into one work that consequently addresses multiplication, duplication and the visual order of the grid. But because Rosen's works walk the line between the beautiful and the grotesque and because they are undoubtedly not machine-made, they are a far cry from the Minimalist industrial austerity that the grid connotes. Rosen seems to let the clay and the glaze interact without much intervention, contemporizing and Westernizing the Japanese ceramists' interest in letting the material speak, while also taking a cue from Peter Voulkos's irreverent treatment of the medium.

Jeff Mongrain's aggregate body of work is wide ranging, but understatement and perception are its leitmotifs. For example, a perforated, bell-shaped form that hangs from the ceiling, suspend-

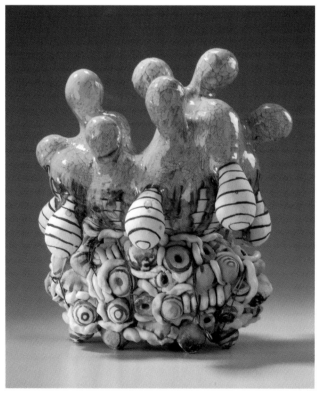

Annabeth Rosen, *Untitled #18* (Mallow), 2006, glazed ceramic, 17 x 15.5 x 9.5 inches.

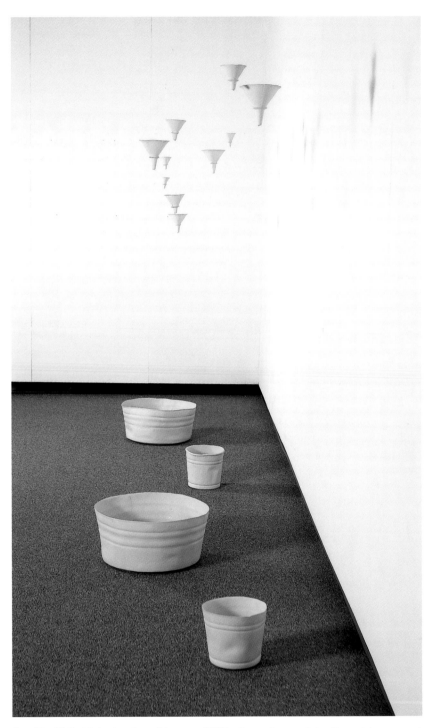

Jennifer Holt, *Metaphor for a Memory*, 2005, slip cast porcelain, thread, ice, sound, dimensions variable.

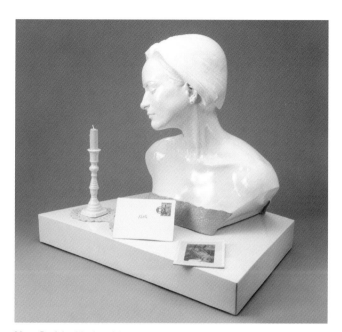

Nan Smith, *Kelli II*, 2007, airbrushed and glazed earthenware, ceramic photo decal, 20 x 24 ½ x 17 ½ inches. Photo credit: Cheuvront Studios, Gainesville, Florida.

Nan Smith stages life-sized, female, figurative representations in dynamic vignettes that speak equally of the individual characters and of the relationship between them. She continues the age-old human endeavor to understand our surroundings by recreating and contextualizing Self. When the viewer enters, she becomes a participant and, like a visitor to Bernini's St. Peter's, complicates the theatricality of the crafted scene. Smith portrays most of her women with their eyes closed, suggesting that, were they animate, they would experience the world with senses other than sight. She may be referencing classical sculpture as it appears today, the once-painted eyes now blank and unseeing. Other figures by Smith are faceless, a void where the head should be, emphasizing absence rather than presence.

Viola Frey was a figural ceramic pioneer, but besides a common subject and medium, the similarities between her work and Smith's are few. Smith's figures are more realistic and psychologically charged than are Frey's. Smith chooses to represent youthful women, at the time of their fullest potential, on the verge of maturity, rather than Frey's wide-range of types and ages. In fact,

Smith combines casts of body parts from multiple women to create a single sculpture, appropriating the most perfect traits of each of her models and synthesizing them into a truly idealized figure. But there is a connection between Frey and Smith, since Frey was struck by how her works related to each other and to whomever walked through the studio door, stating, "I think [an artist] has just one installation piece, and all they do is keep on repeating the same piece over and over again."[7] What Frey serendipitously noticed as a potential force in her art, Smith deliberately achieves in hers. Smith has put Frey's musings into practice by combining her figures to create a message that goes beyond what each of them could say individually, and by making their relationships an important factor in her art.

In Jennifer Holt's *Metaphor for a Memory*, cast porcelain funnels filled with ice float above vessels situated on the floor. All of the funnels are at about eye level, so the presence of the ice is apparent only through its remnants, drips of water, the sound of which is emphasized by an audio component crafted by the artist. Each drop of water represents a brief moment in time, ephemeral, never to be recaptured, except as a

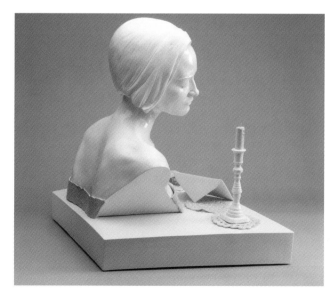

Nan Smith, *Kelli II* (alternate view), 2007, airbrushed and glazed earthenware, ceramic photo decal, 20 x 24 ½ x 17 ½ inches. Photo credit: Cheuvront Studios, Gainesville, Florida.

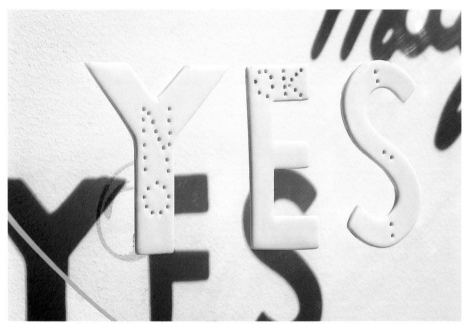

Holly Hanessian, Detail from *MAYBE & YES*, 2007, wall installation, plexiglas, monofilament, porcelain.

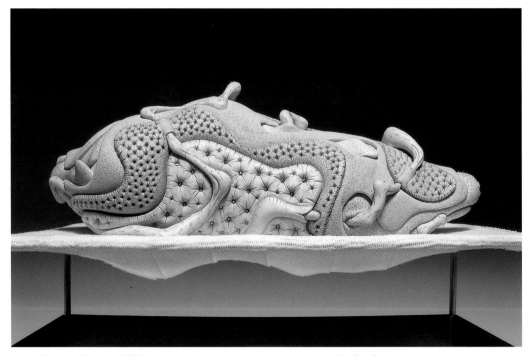

Jason Briggs, *Crème*, 2002, porcelain, hair, gauze, stainless steel, 13 x 8 x 6 inches.

memory. "By exploiting the fragility and translucency of porcelain, I employ the process of casting on metaphorical terms," Holt states. "A mold creates a memory of an object, picking up the traces of its use and history."[8] Through looking at and listening to *Metaphor for a Memory* we are psychologically transported to a previous place and time, consequently becoming more aware of our own immediate physical presence and how it relates to its surroundings.

The Hybrid

Holly Hanessian comments on the ambiguity of communication in juxtapositions of words made from clay with other images and objects, sometimes found books. For example, in *Fate* Hanessian spells out the work's title in cursive letters crafted from clay. Seductive, feminine and Victorian looking, the writing style evokes associations with the repression and subversiveness of that era. Each letter is suspended from a short ceramic chain that hangs from a hook, also ceramic, so the shadow of the chain and the letters create a two-dimensional version of the three-dimensional source. Together the hooks' profiles spell the word "luck." Hanessian states "I continue to question how, why and where we end up in life; is it good fortune, destiny or the result of choice?" By creating text with clay she comments on the potential for multiple layers of meaning inherent to both of these media of communication. The meaning of a word changes depending upon the situation in which it is verbalized, the intonation of the speaker, and the social status and emotional state of the receiver. Clay, too, is easily molded and changed; its malleability is one of its most valuable characteristics. Sometimes it is circumstance, and other times intentions, that determine results.

Jason Briggs fetishizes what look like body parts, both human and non-human. His forms tend to be closed and elliptical, lap-sized, their surfaces comprised of oddly shaped swaths of clay, each patterned differently from its neighbor. Some sprout hair. *Crème* is displayed on a steel stand, like a specimen in a clinic, and looks like it could breathe, expanding and contracting slowly and methodically. It is alien, and oddly frightening. Briggs states, "When one views pornography, one is thinking about touching, about how it would feel.

I want my work to elicit a similar response: 'What if I could touch it?'"

Briggs has made pots, and in the context of functional wares, the surfaces of his more recent objects such as *Crème* look like bas-relief interpretations of drawn patterns on traditional vessels. Briggs quickly grows from these conservative roots in two-dimensional decoration; the indentations become orifices, punctures become openings, the utilitarian becomes the organic and then the scientific. These objects cross the natural with the manufactured, and the animate with the inanimate.

John Byrd hybridizes the real and the fake: his *Dirty Skinned Savages* twists the idea of the memorial into a folksy scene with a macabre bent. A rickety, wooden wagon, mired in mud dominates the miniature vignette. Lying next to it sprawls a wounded figure, guts spilling from an abdominal wound. But it is not a human face that crowns this torso, but rather the taxidermic head of a rodent, immersed in resin. Once this odd juxtaposition becomes clear, the rodent visually controls the narrative and questions human relationships to animals and to all other aspects of the natural world. Who, really, dominates?

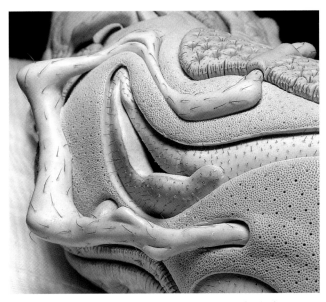

Jason Briggs, Detail of *Crème*, 2002, porcelain, hair, gauze, stainless steel, 13 x 8 x 6 inches.

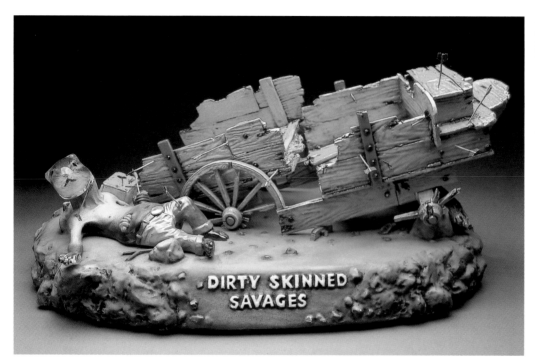

John Byrd, *Dirty Skinned Savages II*, 2006, ceramic, mixed media, 9 ¾ x 21 x 13 inches.

Wendy Walgate, *Five Litres: Avitus, Domesticus, Reptilis*, 2007, white earthenware, slipcast, glazed, glass lab beaker, metal tags, 12 x 8 x 8 inches each. Photo credit: John Goldstein.

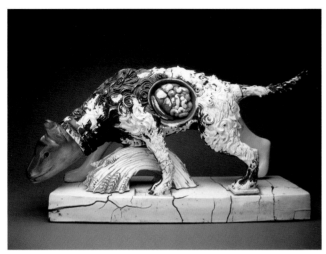

John Byrd, *Untitled* (Hunting Dog), 2004, porcelain, taxidermy, mixed media, 17 x 33 x 22 inches.

Dirty Skinned Savages plays upon the myth of the American West and its alliance with the nineteenth-century concept of Manifest Destiny, the belief that the United States was destined to expand from the Atlantic seaboard to the Pacific Ocean; it has also been used to advocate for or justify other territorial acquisitions. The Homestead Acts, passed by President Abraham Lincoln, legitimized this conviction and became vital to westward expansion by offering free land in the West to those willing to farm it. This process left many "dirty skinned savages" in its wake and eventually led to the corralling of Native Americans into reservations. Byrd suggests that the unfair treatment of Native Americans on the part of the Euro-dominated U.S. is only one example of injustice. And, in the end, the conqueror gets his due, morphing into a rodent.

Byrd's other recent work speaks of injustices in a more generalized way, and questions the hierarchy of the animal kingdom and the food chain. "In regards to the potential empathic response of the viewer," he states, "I find that people are apt to draw their own defining ethical lines in regards to their connection with animals..."[9] Many of his works convey the quality of a specimen, the resin[10] substituting for more typical formaldehyde. In *Perfectly Balanced Between Reaped and Sewn* (2007), a rodent peers out of the faceplate of a robot. In *Hunting Dog* (2004), the taxidermic head of a fox

is attached to a ceramic representation of the body of a dog, complete with a window on his inner intestines, as if a science experiment. Given that dogs usually track foxes, Byrd twists the expectations of who hunts and who is hunted, and asserts the implausibility of the two becoming one.

Wendy Walgate uses molds from kitsch objects that represent an array of subjects (butterfly, flowers, deer, cats, owls, bears, horses), and from them casts new ceramic pieces, each of which she glazes a single color, glossy and bright. She then piles pieces, often of like-palette, into stacks. These sculptures have been referred to as comments on industrial agriculture's commodification of farm animals. But their overall aesthetic is apolitical and speaks of grandma's cupboard,

Wendy Walgate, *As I Was Going Carriage*, 2007, white earthenware, slipcast and glazed, vintage wooden carriage, 29 x 21 x 10 inches.

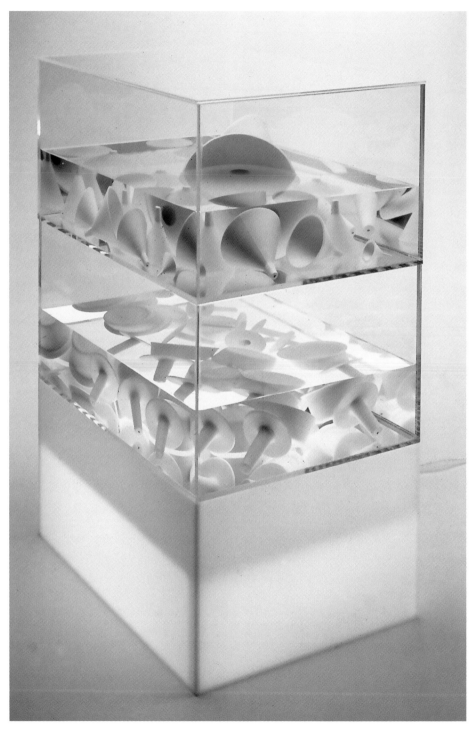

Julie York, *Blindness*, 2003, mixed media, 27 x 18 x 13 inches.

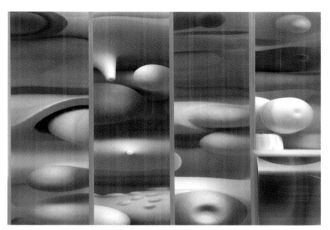

Julie York, Detail from *c-space series*, 2006, porcelain, glass, plastic.

Like Walgate, Julie York reproduces found objects in slip-cast clay. She often juxtaposes them with ubiquitous metal, glass and plastic objects from everyday life, presents them in pseudo-scientific environments that emphasize their importance and, in her words, "describe them anew." In *Blindness*, for example, York submerges her cast objects in water and displays them in a tank, prompting associations with the loot from a sunken ship displayed in a natural history museum. The format also nods to Jeff Koons' *Three Ball Total Equilibrium Tank (Two Dr J Silver Series, Spalding NBA Tip-Off)* of 1985, smack in the middle the consumerist decade. Koons, a former stockbroker, made a series of works presenting consumer items in glass cases. Removed from any practical purpose, they become fetish objects to be gazed at and admired, like York's reproduction of material culture. But according to Koons, the basketballs suggest death, the ultimate state of being.[14] So Koons' intentions parallel those of Damien Hirst's tank pieces from a few years later, which incorporate dead and sometimes dissected animals preserved in formaldehyde. The best known of these suspended fatalities is the tiger shark in *The Physical Impossibility of Death in the Mind of Someone Living* (1991). In York's *Blindness* the objects seem sunken and grounded, rather than floating. But the use of liquid as a preservative of a moment in time, and of objects speaking to an overarching condition, connects York to both Koons and Hirst.

and of preciousness based on sentiment, rather than on intrinsic value. The original objects were mass-produced, and thus draw into question the use of the term "original" as a descriptor. However, Walgate's recasts are selective in number and, of course, differ in intended use from their predecessors. One might interpret Walgate's work as an indictment, condemning the original intention of the decorative, consumer products that are her source material, since they populate the planet with unnecessary stuff. Walgate's words deny this interpretation. "I embrace it, it's all part of clay, part of ceramic history."[11]

Walgate, of course, is not the only artist to celebrate kitsch, an aesthetic that has come to be accepted in the past several decades, with Jeff Koons as its most high-profile practitioner. Clement Greenberg, the influential mid-century American critic, thought of kitsch and high art as antithetical, and in 1939 argued this in his controversial essay *Avant-Garde and Kitsch*.[12] Based on Marxist models, Greenberg believed that the avant-garde arose in order to defend aesthetic standards from the decline of taste involved in consumer society, which was symbolized by kitsch. Then, in 1964 Susan Sontag reversed this argument and defended the lowbrow in her essay *Notes on Camp*,[13] stating that camp involved an aesthetic of artifice rather than of nature. "The ultimate Camp statement: it's good because it's awful." Sontag's ideas provided the groundwork for Pop Art and opened the door to artists such as Walgate.

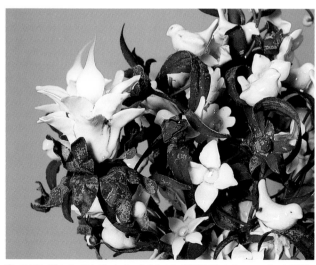

Cynthia Giachetti, Detail of *Alight*, 2007, Katrina rusted 19th-century chandelier, porcelain, steel.

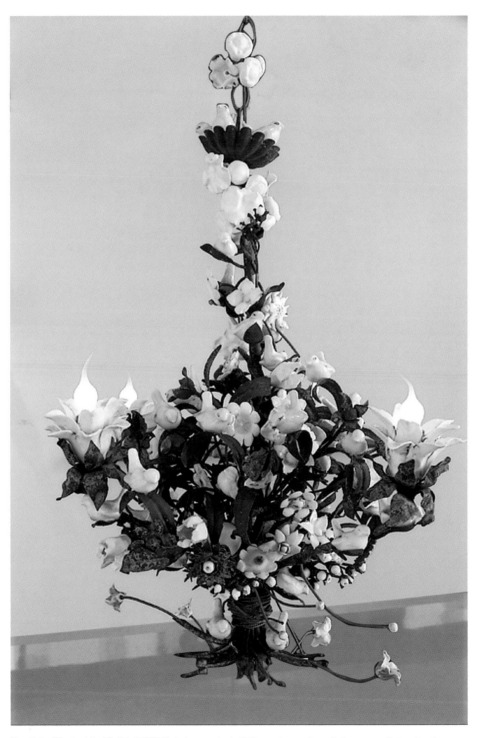

Cynthia Giachetti, *Alight*, 2007, Katrina rusted 19th-century chandelier, porcelain, steel.

Memento mori works are haunting commentaries on the fragility of life, the recurrent theme in the sculptures of Cyndy Giachetti. In works informed by such diverse influences as social and Southern family history and folklore, the ecological impact of global warming, the Katrina disaster in Louisiana, and the metaphysical artifact of the Catholic shrine or reliquary, Giachetti integrates found objects and natural imageries. She writes of *Centerpiece* that it is "a welcoming and a warning" comprised as it is of delicate floral elements and rusted, twisted tableware that represents detritus from the aftermath of the recent hurricane. Giachetti finds sympathetic geometry in such relics as Victorian architectural fragments, discarded bed springs, and "light fixtures that mimic flowers and finials." As the underlying matrix for her clay figures, Giachetti makes capital of the resonant or even double meanings of her titles: *Alight* is a found chandelier which hangs at half-mast for the storm destruction of the city of New Orleans, yet is vivid with birds and flowers; *Reliquary* is a sewing table re-imagined as a new repository for collected insect specimens and the random surviving implements of lace-making—things that remained; *Cobbled* is the title of a surrogate rooftop where wingless doves perch in a state of anticipation of rescue or else wait quietly in acknowledgment of loss. Conceptually poetic and yet acutely attuned to current events, Giachetti's works marry household artifacts and sculptural elements into a postmodern hybrid that is both global consciousness and personal symbolism.[15]

The Categories

The artists in *Full and Spare* share a common material and an impulse to respond to some aspect of the complexity of the contemporary human condition, but these two connections are trumped by the uniqueness of each of their messages and aesthetics. This is not unexpected. Since the advent of postmodernism in the 1960s, art has become increasingly pluralistic, and the art world more accepting and open to challenging expressions.

But there are some common themes: *fullness* and *spareness* are antonyms intended to establish the opposing poles of effort, different ways of working. In a very general sense, the artists harnessing an aesthetic of generosity (the *Full*) draw primarily from nature, and either capture or dissect its beauty and complexity. This includes Susan Beiner, Ying-Yueh Chuang, Bean Finneran and Wendy Walgate, all of whom combine simple forms into something greater than their individual units to create compositions that are self-contained worlds. On the other hand, works with a more minimal aesthetic (the *Spare*) draw from industry or the manufactured and may be more likely to define the space in which they exist and, conversely, to be dependent upon their surroundings to lend them additional meaning. Some work by Jeanne Quinn, Jeff Mongrain and Jennifer Holt fall into this camp.

I have located three other frames of reference, and most of the artists in this exhibition negotiate more than one of them: the decorative, spatial manipulation and hybridism. For example, Nancy Blum addresses fullness in the sheer number of objects she incorporates, but spareness in her palette. Her flowers are decorative because they are patterned, but also hybridize nature and the industrial. The same can be said of Ying-Yueh Chuang's creatures. Susan Beiner and Jeanne Quinn are interested in nature and the decorative, and also in manipulating space. Jeremy Hatch is full in his detail and spare in his lack of color. One could go on, although categories are not meant to pigeonhole. Instead they instigate new ways of seeing and thinking about the art, in all of its variety and brilliance.

—KB

Kate Bonansinga is Director of the Stanlee and Gerald Rubin Center for the Visual Arts at the University of Texas at El Paso.

1 Jean-François Lyotard, "The Postmodern Condition," reprinted in *Art in Theory, 1900-1990*, edited by Charles Harrison and Paul Wood, Paul Blackwell, 1992, p. 999.

2 See Dandelet, Thomas, "Setting the Noble Stage in Baroque Rome: Roman Palaces, Political Contest, and Social Theater, 1600-1700," in *Life and the Arts in the Baroque Palaces of Rome*, edited by Stefanie Walker and Frederick Hammond. New Haven: Yale University Press, 1999.

3 Jean Baudriallard, *Simulacra and Simulation*, trans. Sheila Faria Glaser (Ann Arbor: University of Michigan Press, 2002), 2.

4 E-mail exchange with the artist, summer 2005.

5 Bean Finneran in email correspondence with Kate Bonansinga, 16 September 2005.

6 Linda Sikora, brochure for exhibition at the Stride Gallery, Calgary, Canada, March/April 2006.

7 Richard Whittaker, "Works and Conversations: Who Makes Originals, Ever? A Conversation with Viola Frey," www.conversations.org, November 30, 1999.

8 *Ceramics Monthly*, May 2007, 42.

9 http://www.garthclark.com/exhibit

10 Formaldehyde is used in the manufacture of some resins.

11 http://walgate.com/PDF/ChromaZooSeries.pdf

12 Reprinted in Greenberg, Clement. *Art and Culture: Critical Essays*. Boston: Beacon Press, 1961.

13 Susan Sontag, *Against Interpretation and Other Essays*. New York: Farrar, Straus and Giroux, 1966.

14 http://www.tate.org.uk/servlet/ViewWork?workid=21383&tabview=work

15 Cynthia Giachetti, *Artist's Statement*.

[facing page] Holly Hanessian, Macro-detail from *Sperm & Eggs*, 2007, porcelain, dimensions variable. Photo credit: Jon Nalon.

SUSAN BEINER

NANCY BLUM

JASON BRIGGS

JOHN BYRD

YING-YUEH CHUANG

BEAN FINNERAN

CYNTHIA GIACHETTI

HOLLY HANESSIAN

JEREMY HATCH

JENNIFER HOLT

JAE WON LEE

JEFFREY MONGRAIN

JEANNE QUINN

ANNABETH ROSEN

NAN SMITH

LINDA SORMIN

WENDY WALGATE

JULIE YORK

The most recent concerns in my work deal with making what is organic synthetic. In today's world, most everything is manufactured from artificial materials. This extends to what was once all natural. Genetically altered foods, cloned animals and the hybridization of everything. This has led me to want to use additional materials that are a result of an industrial process such as foam, plexiglas and rubber.

My current work displays a shift to ideas about installation, covering an expanse of space. My interest is fueled by elements of layering, fragmentation, multiplication, juxtaposition and complication. Intense brilliant color reveals an obviously artificial man-made reality. Color is swirled together in rhythmic sequences mirroring the activities of a microscopic sample or aerial topography. The encrustations are abstracted from real plant life, allowing the viewer to proceed into the interior pattern of a stylized manufactured plastic plant life. So as viewers, we are challenged by our own perceptions of what is authentic and what is not. —SB

Susan Beiner is an Assistant Professor at Arizona State University, Tempe.

Selected Exhibitions & Awards: 2007—*Out of Hand*, Society of Contemporary Craft, Pittsburgh. 2006—Artist Residency, The Clay Studio, Philadelphia. Independence Foundation Artist Grant, Philadelphia. *The Yixing Effect: Echoes of the Chinese Scholar*, Holter Museum of Art, Helena, MT. *The 4th World Ceramic Biennale*, Icheon World Ceramic Center, Korea. *Ceram-a-rama:California Dreamin'*, ASU Ceramics Research Center, Tempe. 2005—*Clay From Molds*, John Michael Kohler Arts Center, Sheboygan, WI. *Excess*, The Clay Studio, Philadelphia. 2004—Artist Residency, Archie Bray Foundation for the Ceramic Arts, Helena, MT. 2003—Artist Residency, International Ceramic Center, Guldagergard, Skaelskor, Denmark. *Deliciously Decadent*, Princessehof Keramiekmuseum, Leewarden, Netherlands. *Recent Acquisition*, Long Beach Museum of Art, Long Beach, CA. *Reinventing Pleasure: Ornamentation in Contemporary Ceramic Art*, University Art Gallery, San Diego University, San Diego, CA. *59th Ceramics Annual Exhibition*, Ruth Chandler Williamson Gallery, Scripps College, Claremont, CA.

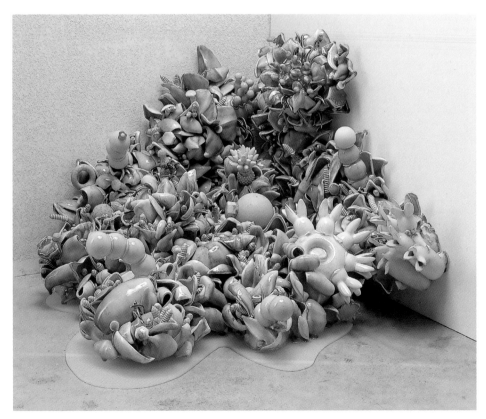

Susan Beiner, *Rather Than Obliquely Encoded*, 2005, porcelain, acrylic, rubber, 32 x 38 x 44 inches.

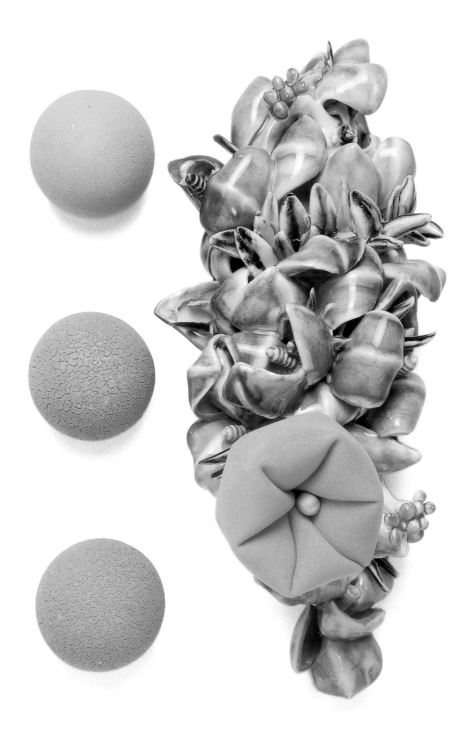

Susan Beiner, *Yellow Mountain*, 2006, porcelain, polyfil, foam, 13 x 7 x 6 inches.

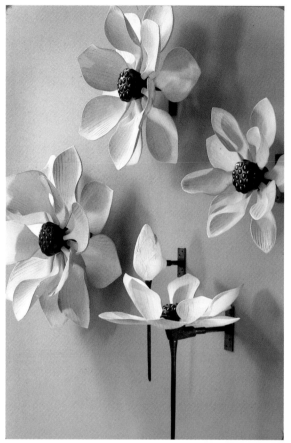

As an artist I work in both sculptural and two-dimensional mediums. My sculpture like my drawings depict the intensity, autonomy and mystery of the natural world. Each piece offers a ground in which lush, active plant life sprawls unpredictably across the page and the wall. Building layer upon layer of line and color, the space becomes dense with energy and activity. When one looks into a work, the looking is rewarded by multiple moments of visual complexity. Drawing from both Eastern and Western visual cultures, Chinese plum blossoms mingle with Germanic botanical renderings; spirographs add a pseudo scientific, techno-reference and all combine to create a thriving utopia. The drawings and sculpture are robustly erotic, like the sculpted flower itself, purporting a sexuality that is simultaneously male and female. As a natural response to the obsessive qualities of line and repetition, I want the act of looking to seduce the observer into meditation. The underlying intention is to create a trance like rhythm that makes the looking experiential. —NB

Nancy Blum lives and works in New York City. She is represented by Pentimenti Gallery in Philadelphia, Judy Ann Goldman Fine Arts in Boston, and Romo Gallery in Atlanta.

Selected Exhibitions & Awards: 2007—*Recent Work*, Judy Ann Goldman Fine Art, Boston. *Drawing and Sculpture*, Pentimenti Gallery, Philadelphia. Three Person Exhibition, Romo Gallery, Atlanta. 2006—Peter S. Reed Foundation Grant, New York. *Nature Unbound*, Brooklyn Botanic Garden, Steinhardt Conservatory Gallery, Brooklyn. *The Drawing Show*, Conduit Gallery, Dallas. 2005—*Drawings*, Kiang Gallery, Atlanta. *On-Site Artist Projects*, Visual Arts Center of Richmond, Richmond, VA. *Fleurs*, Pentimenti Gallery, Philadelphia. *Mid-Atlantic Fellowship Exhibition*, Maryland Art Place, Baltimore. 2004—*New Work*, Pentimenti Gallery, Philadelphia. Mid-Atlantic Arts Foundation Creative Fellowship Grant, New York. *Arthouse*, Margaret Thatcher Projects, New York.

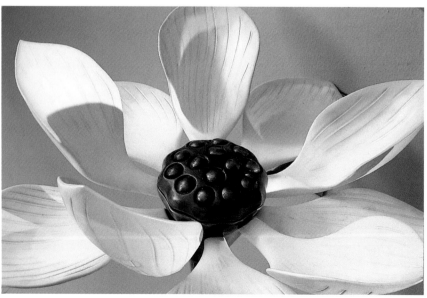

Nancy Blum, Details of *Lotus Pond*, 2003-06, bronze, porcelain, steel, 96 x 120 inches.

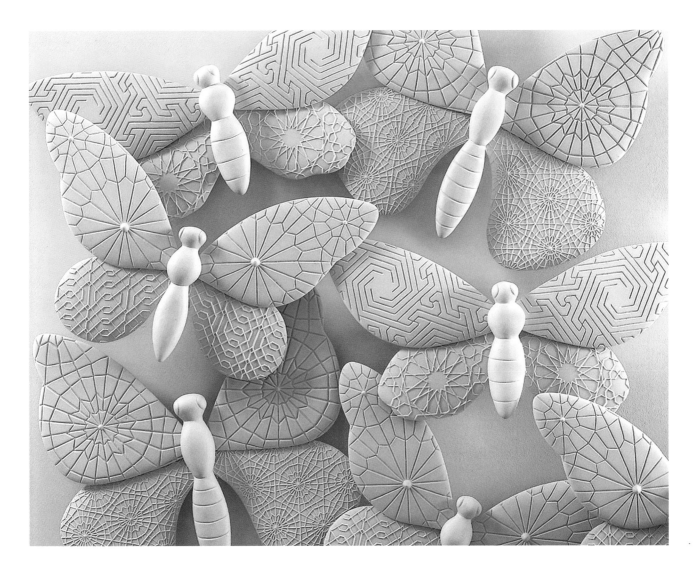

Nancy Blum, Details of *Butterflies*, 2005, china clay and paint, 12 x 15 x 2 inches each of 90 forms, overall dimensions variable.

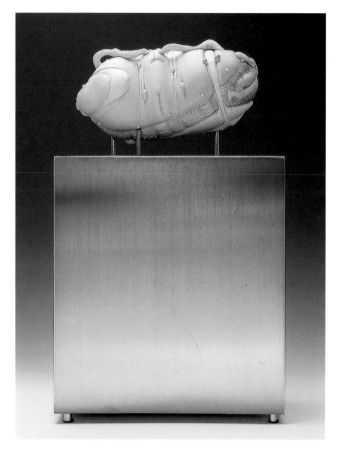

I am searching for a fresh perspective. I strive to create an object I've never quite seen before—one whose inherent mystery and intrigue quietly insists upon viewer interaction. An object begging to be examined in much the same way a child investigates the world: with wonder, curiosity, and also trepidation. It's very important that the work be challenging—it encourages the viewer to consider carefully what is compelling them. I would like my work to exist not as the ubiquitous "art object," but as something more enigmatic—foreign yet familiar, handmade yet somehow organic. Rather than suggest nature, in my own way I am seeking to create it.

Though these objects contain strong visual references, I am more interested in the implied tactile ones; the things that stir in me a compulsion to touch. Beyond other external inspiration lies this basic, primal impulse. I recognize—and act upon—a profound desire to push, poke, squeeze, stroke, caress, and pinch. I intend for my pieces to invoke a similar sort of temptation. Apparent sexual references, along with an extravagant, fetish-like attention to surface, elicit a tacit response: "What if I could touch it?" —JB

Jason Briggs teaches ceramics at Belmont University in Nashville, Tennessee.

Selected Exhibitions & Awards: 2007—Purchase Award, *NCECA Clay National Biennial Exhibition*, Kentucky Museum of Art and Craft, Louisville. Third Place, Virginia A. Groot Foundation Fellowship. *BLUE: Invitational*, East Central College Gallery, Union, MO. 2006—Individual Artist Fellowship, Tennessee Arts Commission. *Glimpse*, Tennessee Arts Commission Gallery, Nashville. 2005—XXX, Santa Fe Clay, Santa Fe, NM. 2004—*Biomimicry: The Art of Imitating Life*, Herron Fallery, IUPUI, Indianapolis. 2003—*Art of Tennessee*, Frist Center for Visual Arts, Nashville. 2002—Ceramic Sculpture Award, *Craft USA 2002*, Silvermine Guild Arts Center, New Canaan, CT. Second Place, *Red Heat: Contemporary Work in Clay*, University of Tulsa, Tulsa, OK. San Angelo National Ceramic Competition, Museum of Fine Arts, San Angelo, TX.

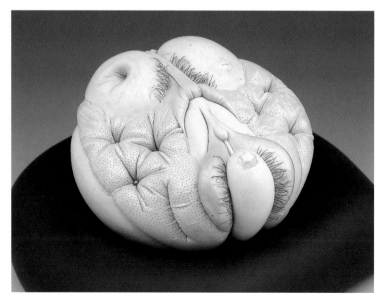

[*above*] Jason Briggs, *Polly*, 2007, porcelain, hair, rubber, stainless steel, 9 x 4 x 13 inches; [*left*] *Squirt*, 2006, porcelain, hair, rubber, stainless steel, 10 x 8 x 8 inches. [*facing page, top*] Jason Briggs, *Crush*, 2007, porcelain, hair, rubber, stainless steel, 12 x 7 x 7 inches. Collection of George D. Clark, Jr. [*facing page, near right*] *Flirt*, 2006, porcelain, hair, Revlon, stainless steel, 12 x 7 x 6 inches; [*facing page, far right*] Detail of *Flirt*.

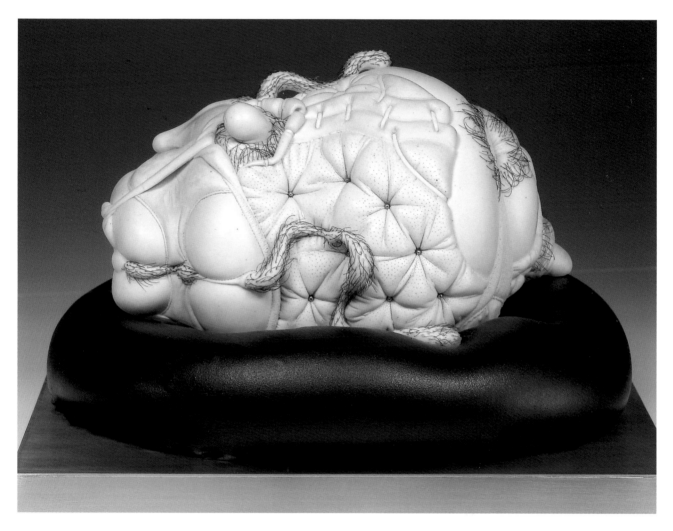

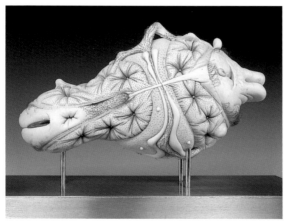

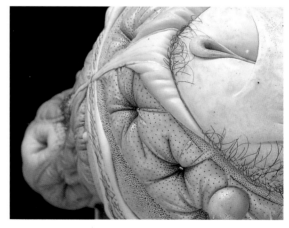

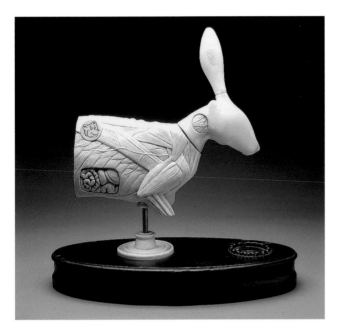

I am interested in the nature of the object and the perception of finely crafted skill specifically as it is used to exhibit a persistent commitment to an idea or exploration. Contextually speaking, my work tends to be derivative of specific aesthetic qualities, most often, those that I associate with a personal auto-biography that had little exposure to art outside of what could be consumed in my rural childhood. I am generally interested in assessing a particular hierarchy of materials that I associated with this aesthetic and often apply skilled processes to either contradict or reinforce my understanding of them. While some work might be modeled after objects that might be considered "low-brow," it's never intended to be judgmental. I resent the notion of "kitsch," and attempt to manipulate much of the media to make the work of a quality that separates it from this descriptor.

While a ceramic representation of fauna may be highly realistic, the physical limitations of the clay have it falling short when compared to the specific qualities of an actual animal specimen. I feel that absolutely all people, in one way or another, act to both honor and consume animals. While I am interested in the divergent nature of this relationship, I make no attempt to be a moral compass. That aspect of my work is simply a personal study of my own hypocrisy as a participant in the notion of both honor and consumption. —JB

John Byrd is an Assistant Professor at the University of South Florida in Tampa.

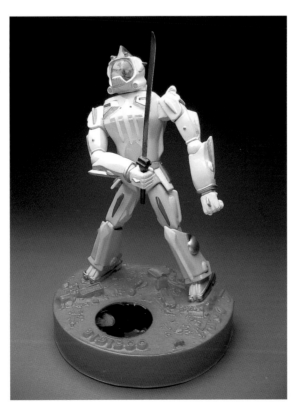

Selected Exhibitions & Awards: 2007—*Point of Departure*, Dean Projects, Long Island City, NY. *Man and Beast*, Garth Clark Gallery, New York. Juror's Award, *4th World Ceramic Biennale*, Icheon World Ceramic Center, Icheon, Korea. *John Byrd & Adelaide Paul*, Garth Clark Gallery, New York. 2006—*One Part Clay*, Dean Projects, Long Island City, NY. *Feral Nature*, University of Texas at Dallas. *Sensibility*, Ash Street Projects, Portland, OR. *Thresholds: Innovative Clay*, Ogle Gallery, Portland, OR. 2005—*UnNatural History*, Kittredge Gallery, University of Puget Sound, Tacoma, WA. *Arcimboldo*, PNW Gallery, Seattle. *Animal Instinct*, Baltimore Clayworks Gallery, Baltimore. *Man's Best Friend*, Santa Fe Clay Gallery, Santa Fe. 2004—Second Place, Virginia A. Groot Foundation Award. *New Works*, Oculus Gallery, Baton Rouge, LA.

[*above*] John Byrd, *Untitled* (*Rabbit*), 2007, ceramic, wood, mixed media, 15 x 15 x 7 inches; [left] *Perfectly Balanced Between Reaped and Sewn*, 2007, ceramic, taxidermy chipmunk, butterfly, precious metal clay, mixed media, 18 x 12 x 10 inches.

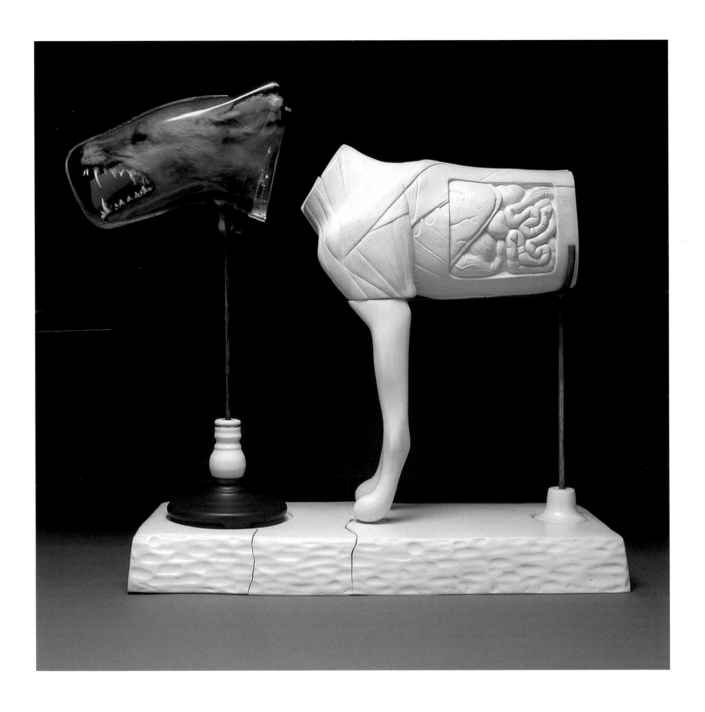

John Byrd, *Simple Anatomy, Slow Burn*, 2006, polished porcelain, taxidermy (fox head), cast plastic, mixed media, 21 x 24 x 9 inches.

Of all the materials I have encountered, clay has proven to be the most forgiving and accessible material, allowing me to explore ideas through the making of objects. Certain ideas I learned while growing up in Taiwan have stayed with me, while others have been abandoned. In this same way, I am selective about how I adapt to Western philosophies and ways of living, leading me to live a hybrid existence with elements from both these cultures. This way of thinking has, in turn, influenced my interest in hybridization, leading me to take elements from plants or sea anemones in order to combine and create forms that are symmetrical and asymmetrical.

From hybrid forms inspired by organic material and imagined objects, my work comes together through a hands-on process and evolves into forms completely different from the initial object. Vegetables, fruits and bones are just a few of the forms that inspire my work and for me, trips to the grocery store become inspirational as I see how color, texture, and shape play off one another in an environment where they are displayed to best exemplify these qualities. As a collector of things, it is the small elements that most people overlook that inspire me most, the pieces that are thrown out or read as undesirable. Take for example the seeds from a pepper. While always thrown out immediately in order to deal with the

pepper itself, I find myself captivated by the seeds, the structure and texture they create.

It is by close observation of plant life that I have noticed how within each structure and environment patterns are created and repeated. In some cases, the specific organizational element of each structure makes the forms and patterns as a whole look integrated and balanced. In other instances, the density of texture increases as the size decreases, while color enhances the structure making it more complete. It is how individual elements, while independent, can also be used like building blocks to create larger units of pattern, which in turn can create even larger patterns exponentially. —Y-YC

Ying-Yueh Chuang lives and works in Toronto, Ontario.

Selected Exhibitions: 2007—*It's A Beauty I*, Terminal 1, Pearson International Airport, Toronto, ON. 2006—*Under the Current*, Solo Exhibition, Burlington Art Centre, Burlington, ON. *From the North: Canadian Ceramics Today*, Invitational Exhibition, The Clay Studio, Philadelphia. *Sweet Wonder*, award Solo Exhibition, New Gallery, Toronto, ON. 2005—*4th Cheongju International Craft Biennale*, Cheongju, Korea. *2nd Biennial International Juried Exhibition*, Herbst International Exhibition Hall, San Francisco. *The 1st International Triennial of Silicate Arts*, Erdei Ferenc Cultural Centre and Art School, Kecskemet, Hungary. 2004—*When the Wind Blows*, Solo Exhibition, Anna Leonowens Gallery, Halifax, NS. *Persistence in Nature*, Solo Exhibition, Harbourfront Centre, Toronto, ON. *Hybrid*, Two-person Exhibition, Plum Blossoms Gallery, New York. *Biomimicry: the Art of Imitating Life, NCECA 2004 Exhibition*, Herron Gallery, Indiana. 2003—*2nd World Ceramic Biennale Korean International Competition*, Korea. *21st Century Ceramics in the United States and Canada*, Cazani Centre Gallery, Ohio. *22nd Gold Coast International Ceramic Art Award*, Surfers Paradise, Australia. *Yuan*, Juried Artist Solo Exhibition, The Clay Studio, Philadelphia.

Selected Awards and Grants: Toronto Arts Council Visual Artist Grant 2007 and 2005; Ontario Arts Council Craft Artists Creative Development Grant 2007, 2006, 2005 and 2004; Winifred Shantz Award for Ceramists 2006; Ontario Society of Artists Juried Exhibition Life Members Award 2006; Canada Council Emerging Artist Grant 2005 and 2004; Best Ceramics Award, Annual Toronto Outdoor Art Exhibition 2004 and 2003.

Ying-Yueh Chuang, *It Blooms on the Day . . . #4*, 2005, multiple-fired from cone 6 to cone 06, ceramics and plexiglas rods, 42 x 42 x 42 cm.

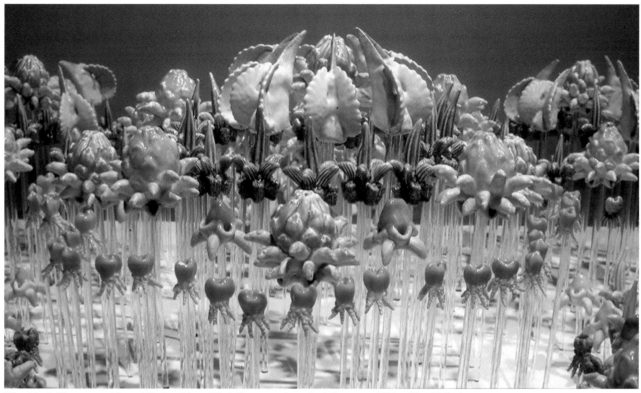

Ying-Yueh Chuang, + *(Cross) Series #1* and Details, ceramics, plexiglas, wood, 24 x 70 x 70 inches.

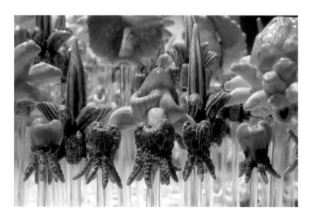

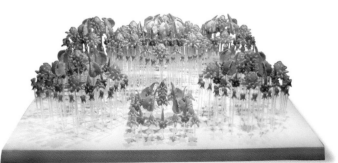

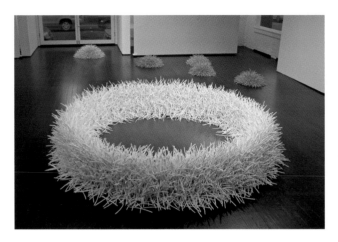

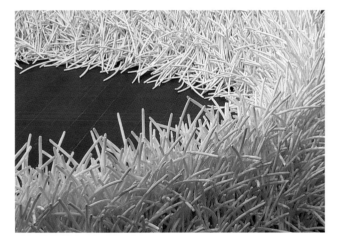

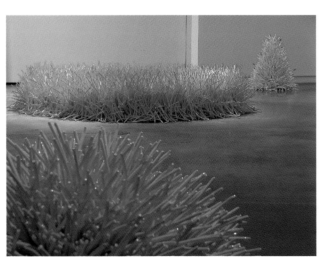

I work with a simple elemental form, a curve made from the most basic natural material, clay. I make and build with hundreds or thousands of these forms. The clay curve connects me to time, the earth, the elements and human culture. The geometry of a curve weaves and allows construction. The clay curves I roll are each similar but unique, connecting them to the natural world where blades of grass are almost the same but never quite the same. The process I use to construct the sculptures follows the patterns in nature. The shapes grow in the allotted space through adding curve after curve. The forms are always transitory, in a space for a given amount of time. The sculptures cannot be moved without taking them apart and reconstructing them. They are built curve-by-curve and disassembled one by one. This process of continual and possible change and transformation connects me to the natural world along with the ordered chaos that comes from organizing thousands upon thousands of individual elements into a form. I garden. I love color and light and the changes light and shadows create. With the sculptures I compose with bright color and form in a space. With its deliberately 'un-natural' color, the work celebrates aspects of nature but does not attempt to mimic it. The constructions are abstract... rings, lines, cones, circles but often evoke real things: sea anemones, coral reefs, haystacks or wind blown grasses. —BF

Bean Finneran lives in Marin County, California. She is represented by Braunstein/Quay Gallery in San Francisco.

Selected Exhibitions & Awards: 2007—*REALMS*, Solo Exhibition, Philadelphia Art Alliance, Philadelphia. *CYCLE*, Solo Exhibition, Baltimore Clayworks, Baltimore. *Meander*, Solo Exhibition, University of Oklahoma, Stillwater. *ABSTRACT SCULPTURE*, The Claystudio, Philadelphia. 2006—*Multiplicity: Contemporary Ceramic Sculpture*, Stanlee and Gerald Rubin Center for the Visual Arts, University of Texas, El Paso (traveled to: Portland Art Center, Portland, OR; Southwest School of Art and Craft, San Antonio, TX; Landmark Arts, Texas Tech University, Lubbock; and San Angelo Museum of Fine Arts, San Angelo, TX). *TOPOLOGY*, Solo Exhibition, Braunstein/Quay Gallery, San Francisco. *SHIFT*, Solo Exhibition, PDX Contemporary Art, Portland. 2005—*Up/Down/Around*, Gallery 555 Oakland Museum of California at City Center, Oakland, CA. *Slow Time/Play Time*, Mills College Art Museum, Oakland, CA. *Pushing the Limits*, John Michael Kohler Arts Center, Sheboygan, WI. *Tales from the Kiln*, San Jose Museum of Art, San Jose, CA. 2002—*Bean Finneran: Recurrence*, Kemper Museum of Contemporary Art, Kansas City, MO.

"*Then look at the human anatomy. We are all
curved surfaces, curving structure, curving
muscle and sinew. This form evolved because
it minimizes the amount of materials and
maximizes structural strength.*"

—*Eugene Tsui*

[*facing page, top*] Bean Finneran, Installation
at PDX Gallery: *White Ring & Sea Forms*,
2006, low fire clay with glazes and acrylic
stain, dimensions variable. Photo credit:
Bill Bachhuber; [*facing page, middle*] Detail
of *White Ring*, 15,000 curves, 6 feet diameter.
[*facing page, bottom*] 2005 Installation at Gail
Severn Gallery: *Red Dome* (5000 curves, 2.5 x
2.5 feet), *Yellow Ring* (17,000 curves, 6 feet in
diameter), *Yellow Cone* (6000 curves, 3.5 x 3.5
feet). Photo credit: Max Finneran. [*above*] *Red
Ring*, low fire clay with glazes and acrylic stain,
4 x 6 feet. [*right*] *Red Core*, low fire clay with
glazes and acrylic stain, 1000 curves, 3 feet in
diameter. Photo credit: Joe Schopplein.

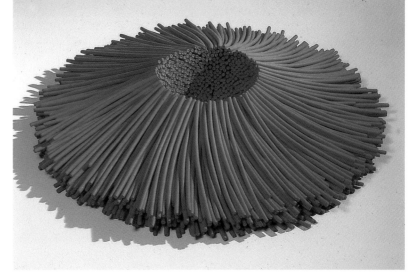

My work deals with a profound sense of loss and the potential for metamorphosis. My pieces are reminiscent of geology and archeology's concerns with the layering of time, place, absence, presence and process. I have an obsession with history and how related natural phenomena from the past can be revisited in the present. The artifacts and materials in my work appear to be held motionless and represent the evidence of recurring cycles that enter into our contemporary midst.

My work over the past several years has been focused on human frailty and the mystery of existence. I use flowers, birds, insects and domestic wares as metaphors that symbolize loss, tragedy and renewal. I uncover, restore, pile, weave and build motifs in a repetitive manner and often produce work that has odd spiritual overtones. Art for me is both a spiritual and investigative practice. —CG

Cynthia Giachetti lives and works in Baton Rouge, Louisiana.

Selected Exhibitions & Awards: 2007—*Art Melt*, Brunner Gallery, Baton Rouge. *What Remains*, Alfred C. Glassell Jr. Exhibitions Gallery-Shaw Center for the Arts, Baton Rouge. *Post Millennium Exponent*, NCECA 2007, Louisville, KY. 2006—*Butterfly Symphony*, Art Performance, Louisiana State University, Baton Rouge. *Valentine*, Art Performance, Louisiana State University, Baton Rouge. *Public Bodies*, Art Performance, Shaw Center for the Arts, Baton Rouge. *Relapse*, Art Performance, Huey P. Long Pool, Louisiana State University, Baton Rouge. 2005—Foster Gallery, Louisiana State University, Baton Rouge. 2004—*Venus Envy*, Baton Rouge. *Bust*, Art Performance, Art Dept, University of California, Davis, CA.

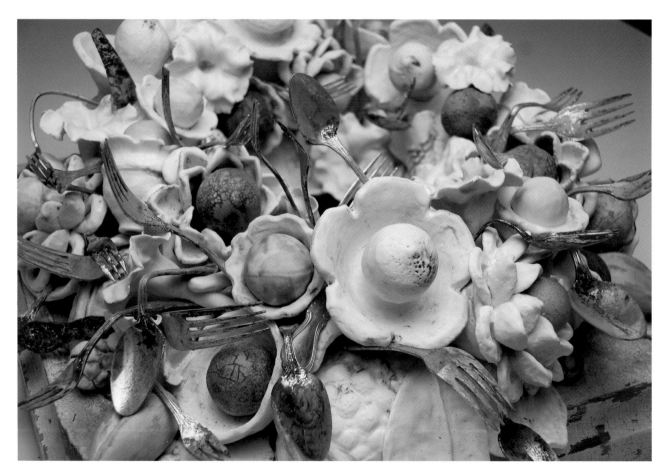

Cynthia Giachetti, Detail of *Centerpiece*, 2007, Victorian column base, porcelain, and Katrina rusted flatware.

Cynthia Giachetti, Installation of *What Remains*, 2007.

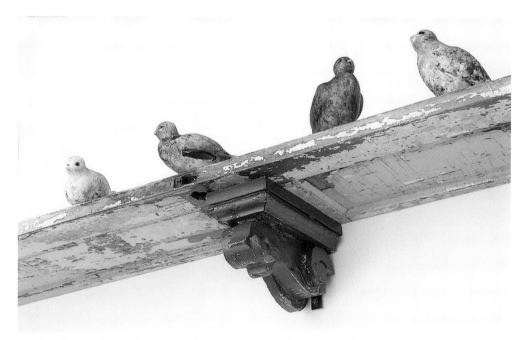

Cynthia Giachetti, Detail of *Cobbled*, porcelain and Victorian gingerbread (architectural corbel and door) from *What Remains*, 2007.

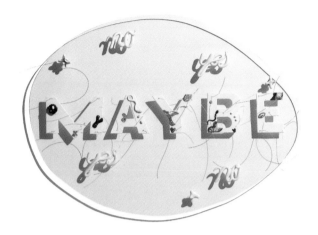

I have used text and the book form as a way of exploring meaning in my ceramic artwork for the last ten years. I create narrative artworks based on life experiences that result from both choice and chance.

Several of my installation works explore complex and difficult life choices exploring ideas relating to death, fecundity and progeny. The texts on these ceramic pieces are partially or easily understandable sentences or words and are placed in or on recognizable objects. My intention is to suggest certain ideas and let the viewer come up with his or her own interpretation.
—HH

Holly Hanessian is an Associate Professor of Art at Florida State University, Tallahassee.

Selected Exhibitions & Awards: 2007—*Fortuity!*, Solo Exhibition, The Ningbo Museum of Art, Ningbo, China. *Memory Lessons*, Solo Exhibition, Appalachian Center for Craft, Smithville, TN. 2006—*16th Annual San Angelo Ceramics Competition*, San Angelo Museum Of Fine Art, San Angelo, TX. *Context: The Written Word*, The Clay Studio, Philadelphia, PA. 2005—*Evermore*, Solo Exhibition, Holland Art Center, Holland, MI. 2005—Juried International Teapot Exhibition, Yixing, China. *The Intensive Spirit*, Juried International Exhibition, Steamboat Springs, CO. *Contemporary Codex: Ceramics and the Book*, University of Maryland, Baltimore. Pyramid Atlantic Art Gallery, Silver Springs, MD. 2004—*On the Wall*, Indianapolis Art Center, Indianapolis. *Michigan Ceramics Invitational*, Saginaw Art Museum, Saginaw, MI. 2003—*Wall Works*, Baltimore Clayworks, Baltimore. *Ceramics USA 2003*, The University of North Texas Art Gallery, Denton, TX. *The Word Made Clay, Ceramic in Its Own Write*, Tile Heritage Foundation, La Jolla, CA. 2002—*New Work*, The Other Gallery, Banff Center for the Arts, Banff, Canada.

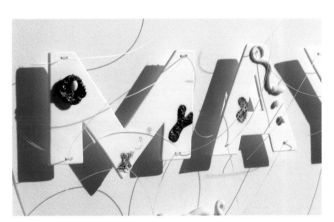

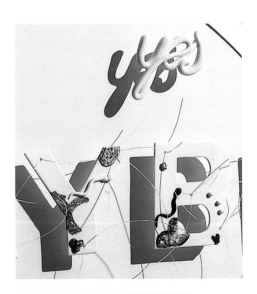

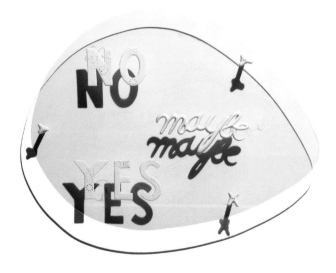

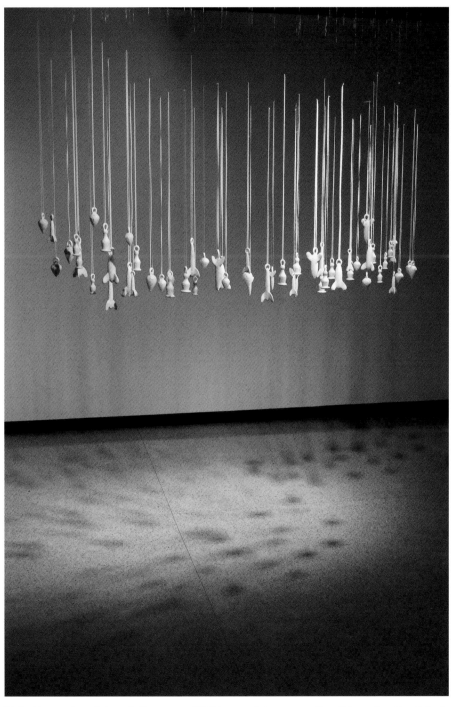

Holly Hanessian, [*above*] *Evermore*, 2005, porcelain, encaustic, ribbon, 9 x 8 x 3 feet.
[*facing page*] *NO, MAYBE & YES* and Details of *MAYBE*, 2007, wall installation, plexiglas,
monofilament, porcelain, dimensions variable.

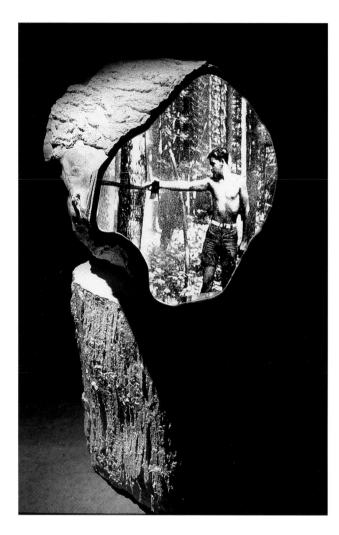

My recent installations—a life-size swing set, a campsite and a tree house—employ the cultural associations of porcelain to invoke a range of conflicting responses. In representing familiar childhood experiences, I seek to question the nature of nostalgia and the in/authenticity of memory. Occupying both social and solitary space, my sculpture is simultaneously monument and souvenir—a mnemonic device that awakens feelings of loss and longing. For me, the act of casting is a symbolic gesture: it freezes a moment in time, recording and preserving forms/events that are impossible to re-live.

My work implicates the viewer as a participant—reflecting back the personal histories, desires and anxieties brought to it. In Still, the instantaneous recognition of a familiar object suggests a simplicity that is deceiving. With a heightened awareness of scale one enters the spatial framework and begins to question the nature of material. There is a compulsion to touch, to confirm or deny what presents itself as reality. It becomes clear that the swing is impossible to use. By placing oneself within the imagined frame one experiences the frustration of desiring what is out of reach. —JH

In 2008, Jeremy Hatch will begin a year-long residency at the Archie Bray Foundation in Helena, Montana.

Selected Exhibitions & Awards: 2008—Truant Fellowship, Archie Bray Foundation, Helena, MT. 2007—Production Grant, Canada Council for the Arts. Artist Residency, European Ceramics Works Center, The Netherlands. *Mobile Structures: Dialogues Between Ceramics and Architecture in Canadian Art*, MacKenzie Gallery, Regina, SK. Ricochet, British Colombia Gallery of Ceramics, Vancouver, BC. 2006—Project Assistant, British Colombia Arts Council. *Tree House*, Canadian Clay and Glass Gallery, Waterloo, ON. *From the North: Canadian Ceramics*, The Clay Studio, Philadelphia. 2005—VADA Award, Contemporary Art Gallery, Vancouver. *Transformations, Burnaby Art Gallery*, Burnaby, BC. 3000+, Charles H. Scott Gallery, Vancouver, BC.

Jeremy Hatch, Detail of *Standing Camp*, 2003, porcelain, backlit print, dimensions variable.

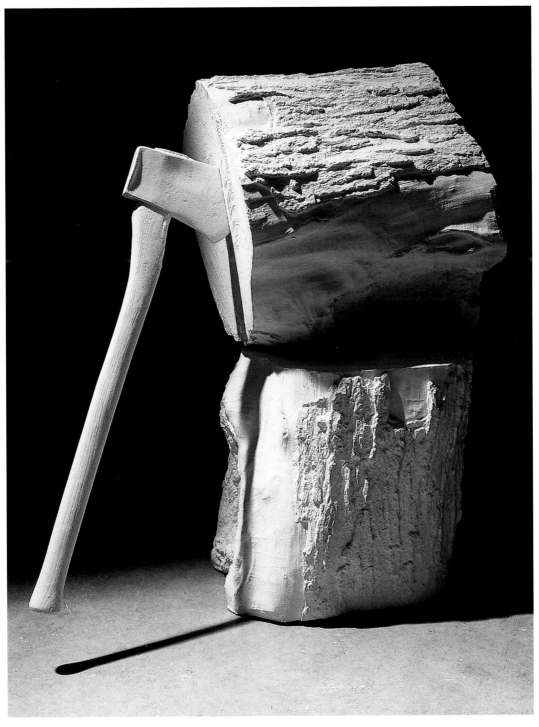

Jeremy Hatch, Detail of *Standing Camp*, 2003, porcelain, backlit print, dimensions variable.

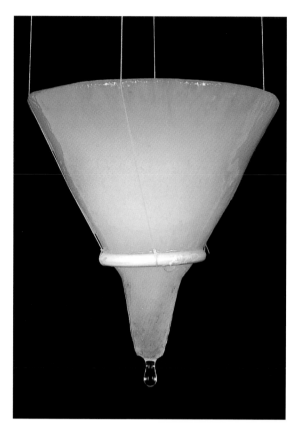

I cast everyday objects in order to explore their meanings and potential to play off the collective memory of the viewer. When experiencing a memory we focus our energy and are transported to another place for a brief moment in time. Like the wall of a thinly cast form, these inner thoughts are separated from the outer world by a thin membrane.

As an installation artist working within the context of a particular place, I become a mediator between site and object, object and viewer, past and present. Juxtaposing cast objects and temporal situations offers a visual metaphor for the phenomena of time and memory, while encouraging viewers to be mindful of their own physical placement in space and time. With the inclusion of sound and melting ice, I am able to offer another layer of experience. These components create a metaphor of how time passes. Like a drip of water, each second we experience becomes a memory. As we travel through space and time, we truly only exist in our memories. —JH

Jennifer Holt is currently an Artist-in-Residence at the Lawrence Art Center in Lawrence, Kansas.

Selected Exhibitions & Awards: 2007—*Silent Conversations*, Craft Alliance Gallery, St. Louis, MO. *NCECA Clay National Biennial*, Kentucky Museum of Art and Craft, Louisville, KY. *Blue*, East Central College Gallery, Union, MO. 2006—*Resident Artists Exhibition*, Archie Bray Foundation for the Ceramic Arts, Helena, MT. *Sage Scholarship Recipient*, Archie Bray Foundation. *Mediations: A Memory of Place*, MFA Thesis Exhibition, Mad Art Gellery, St. Louis, MO. 2004—*Marge Brown Kolodner Graduate Student Exhibition*, The Clay Studio, Philadelphia. 2003—*Best of Ohio, 2003, The Wooster Functional Ceramics Workshop Award for Excellence*, Ohio Craft Museum, Columbus, OH.

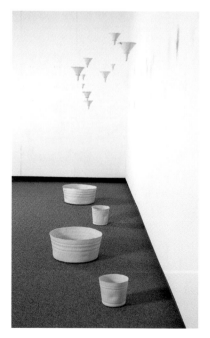

[*above*] Jennifer Holt, Detail of *Metaphor for a Memory*; [*right*] *Metaphor for a Memory*, 2005, slip cast porcelain, thread, ice, sound, dimensions variable; [*facing page*] Detail of *Metaphor for a Memory*.

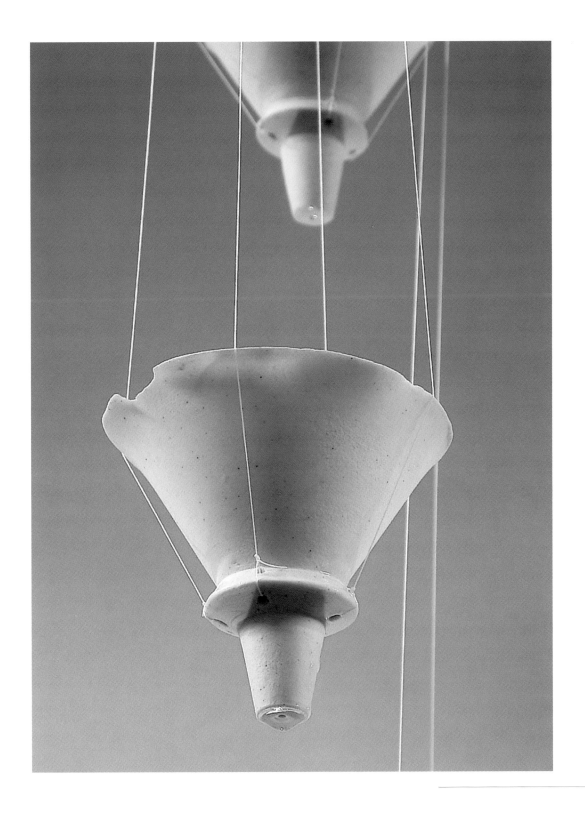

But the thing is, the marvelous thing is, when you first start doing it, you don't even have to have faith in what you're doing. I mean even if you're terribly embarrassed about the whole thing, it's perfectly all right. I mean you're not insulting anybody or anything. In other words, nobody asks you to believe a single thing when you first start out. All you have to have in the beginning is quantity. Then, later on, it becomes quality by itself. On its own power or something. He says that any name of God—any name at all—has this peculiar, self-active power of its own, and it starts working after you've sort of started it up.
—J.D. Salinger, *Franny and Zooey*, 1961.

seeds,
silence.
solitude.
simplicity.

once everything was in the earth,
there was a long period of waiting.
winter has become a right place to think.
there is so little out there.
it's a bid to be non-specific.
a view both elegantly pristine
and eerily absent of life.
the light-filled vision
of the snowed, frozen, or frosted landscape
seems to compress the atmosphere.
a stillness highly charged.

redefine the sublime.
to make visible the interior landscape,
journeying into self.

—JWL, studio notes, winter 2005

[*above and right*] Jae Won Lee, Details of *Frail Hope, Internal Distance: Object III* and *Wallpetal*.

Jae Won Lee is an Associate Professor of Art at Michigan State University and is represented by Paul Kotula Projects, Detroit.

Selected Awards and Exhibitions: 2007—Solo Exhibition, *Of a Moon Garden*, Korean Craft Promotion Foundation, Seoul, Korea. *NCECA Clay National*, Museum of Arts & Design, Louisville, KY. *Winter Dwellings*, Second Street Gallery, Charlottesville, VA. 2006—Solo Exhibition, *Of a Moon Garden*, Harrison Gallery, The Clay Studio, Philadelphia, PA. *Drawing No Conclusions*, Urban Institute for Contemporary Arts, Grand Rapids, MI. *Excess*, Cummings Arts Center, Connecticut College, New London, CT. *The coffee was very slow in coming.*, Paul Kotula Project, Detroit, MI. *Stitch*, Chungmu Gallery, Seoul, Korea. *Minimal/ist*, Archer Gallery, Clark College, Vancouver, WA. 2005—Solo Exhibition, *A Homing Instinct*, Tomado Gallery, Seoul, Korea. *Cheers-*, Revolution Gallery, Detroit, MI. *Art Chicago, International Invitational*, Revolution Gallery, Navy Pier, Chicago, IL. 2004—Solo Exhibition, *Accrescere*, Revolution Gallery, Detroit, MI. 2003—*SOFA Chicago*, Dubhe Carreno Gallery, Navy Pier, Chicago, IL. *Home/land: Artists, Immigration and Identity*, Society of Contemporary Craft, Pittsburgh, PA. *21st Century Ceramics*, Columbus College of Art & Design, Columbus, OH. *NCECA Clay National*, R.B. Stevenson Gallery, San Diego, CA. 2002—Solo Exhibition, *Jae Won Lee*, Gallery Materia, Scottsdale, AZ. *SOFA New York*, Seventh Regiment Armory, New York, NY. *4x10 Ceramic Sculpture*, Phillips Museum of Art, Lancaster, PA. 2001—Solo Exhibition, *Immigrant Flowers*, Embassy of the United States in Germany, Berlin. 2000—Solo Exhibition, *Between the Petals*, Revolution Gallery, Detroit, MI. *Sangamam*, Chitraniketan Art Gallery, Trivandrum, Kerala, India.

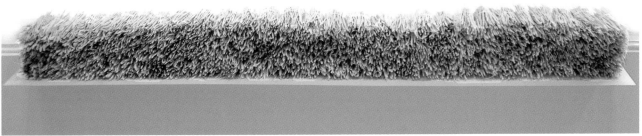

[*top*] Jae Won Lee, *Wallpetal*, 2006, porcelain, foam tape, 90 x 64 x 1/8 inches; [*bottom*] *Frail Hope, Internal Distance: Object III*, 2004, porcelain, monofilament, 8 x 72 x 6 inches.

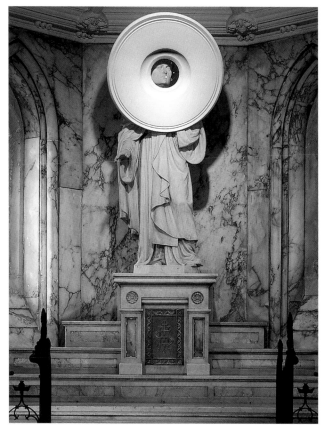

Jeffrey Mongrain creates both gallery-based works and site-specific pieces. The sited works are primarily located in spiritual spaces. His gallery-based sculptures are reductive and generally reference iconic forms. There is a compelling oblique narrative suggested by Mongrain's sculptures that also reflects an autobiographical politic. Scientific findings and religious philosophy are the conceptual foundation of his emotive forms.

Art in America Contributing Editor, Eleanor Heartney: "Jeffrey Mongrain brings a human dimension to abstracted yet iconic forms. Obliquely referencing personal metaphor, history, science, sensuality, and the pervasive echoes of sacred spaces, he astutely balances form and content. Mongrain's richly coded images are visually quiet, physically eloquent and conceptually meaningful."

David Revere McFadden, the Chief Curator of the Museum of Arts and Design: "Jeffrey Mongrain takes the viewer on a journey into the world of experience and meaning on several concurrent levels. Physically and visually, Mongrain's forms are simple, elegant and even austere, drawing upon the humble elements of the tangible world with which we are entirely familiar and comfortable. The form is revealed with grace and virtuosity. At the same time, each of these forms encase mysteries, these are the secrets of association, reference, memory and science that inhabit Mongrain's world."

Jeffrey Mongrain is a Professor of Art at Hunter College in New York City. He is represented by Loveed Fine Arts in New York and The Perimeter Gallery in Chicago.

Selected Exhibitions & Awards: 2007—*The Sculpture of Jeffrey Mongrain: Secrets and Revelations*, San Angelo Museum of Fine Arts, San Angelo, TX. *Jeffrey Mongrain: Sculpture*, Daum Museum of Contemporary Art, Sedelia, MO. *Jeffrey Mongrain*, Schein-Joseph International Museum of Ceramic Art, Alfred, NY. Solo Exhibition, North London Gallery, London. 2006—Archer Gallery, Vancouver, WA. Boston Society for the Arts, Boston. 2005—Solo Exhibition, National Museum of Catholic Art, New York. Solo Exhibition, Diego Rivera Museum, Guanajuato, Mexico. Solo Exhibition, IUN Gallery of Contemporary Art, Gary, IN. *SOFA Armory Exhibition*, New York. 2004—Two Person Exhibition, Newcastle Regional Art Museum, Newcastle, Australia. Solo Exhibition, Principalia Museum, Veracruz, Mexico. Two Person Exhibition, Perimeter Gallery, New York.

[*above*] Jeffrey Mongrain, *The Philosopher's Halo*, 2005, clay, optical lens, gold leaf, 32 x 32 x 8 inches; [*left*] *Northern Tinder*, 2003, resin, styrofoam, light, 74 x 74 x 96 inches.

Jeffrey Mongrain, *Diviner*, 2001, clay, 54 x 19 x 19 inches.

The words decoration and decorum are rooted in the same Latin word, decorus: handsome and seemly. From this implication, decoration constructs the beautiful world in which we behave well. I believe this: when I see graceful ornament, it calms me, making me realize the order of the world.

Medival cartographers believed in the ordered world literally; their maps reveal perfect symmetry. They believed that a perfect God created a perfect world. Symmetry visually represented perfection, and their maps of repeated shapes become decorative patterns.

Playing with symmetry has become an elaborate game to me; I balance paired elements but alter color, scale, or form. Using shapes of maps and decorative motifs, I point to paths traveled, open space, and a merging of internal and external worlds. I attempt to construct a new kind of perfect world. —JQ

Jeanne Quinn is represented by Robischon Gallery in Denver, Colorado. She teaches at the University of Colorado at Boulder.

Selected Exhibitions & Awards: 2006—*Decades of Influence: Colorado 1985-2006*, Denver Museum of Contemporary Art, Denver. 2005—Solo Exhibition, *Perfect Lover*, John Michael Kohler Arts Center, Sheboygan, WI. *Strata: New Perspectives on Ceramics from Scandinavia and the United States*, Skulpturens Hus, Stockholm, Sweden. *Diverse Domain*, Taipei Yingko Ceramics Museum, Taipei, Taiwan. 2004—MacDowell Colony Fellow, Peterborough, NH. 2003—Solo Exhibition, Where I Live, This is What the Sky Looks Like, Formaguppen Galleri, Malmö, Sweden. 2002—*Material Speculations: NCECA National Invitational Exhibition 2002*, H and R Block Artspace at the Kansas City Art Institute, Kansas City, MO. 2001—*Objekt og Installation*, Grimmerhus Museum, Middlefart, Denmark. *Internationaler Porzellanworkshop/KAHLA Kreative*, Museum fur Angewandte Kunst, Gera, Germany. *A Ceramic Continuum: Fifty Years of the Archie Bray Influence*, Holter Museum of Art, Helena, MT.

Jeanne Quinn, *Lacemap*, 2008, unglazed black porcelain, pins, wire, paper, paint, vinyl, 36 x 51 x 4 inches.

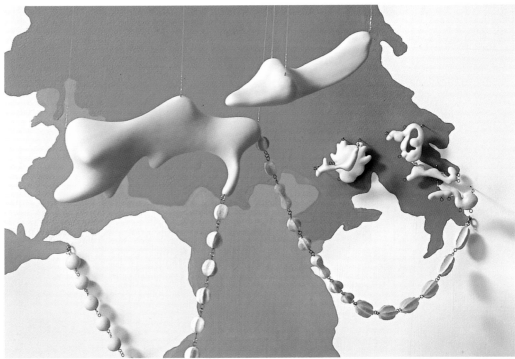

Jeanne Quinn, *The Perfect World*, 2007, porcelain, wire, paint, plywood, 11 x 28 x 4 ½ feet.

I've always needed to work building a momentum, day after day, creating an atmosphere in studio that allows the unexpected to happen, paying attention to the very obvious things before me. My interest is in how my idea penetrates the material.

There is a hierarchy in ceramics, embodied in its history: unfired vs. fired clay, unglazed vs. glazed ware. There is an order, structure, organization dictated by process inherent in the material. Part of my interest has been to tinker with this hierarchy and to question the process in order to represent more about the material itself with my ideas embedded into it and to be able to exploit its strengths as an expressive medium.

I break almost as much ceramics as I make, and I think I learn as much about the work by doing so. By being so focused on a destination for the piece, I overlook shapes and ideas. Much of the work is made with already fired parts broken, reassembled, re-glazed and re-fired with the addition of wet clay elements if necessary. I work with a hammer and chisel, and I think of the fired pieces as being as fluid and malleable as wet clay.

Sometimes, seemingly disparate things, when they're joined, can be utterly convincing. In studio, there is very little randomness, and most things are set in motion from a multitude of forces, and everything counts. There is a conscience attempt to be aware of

unconscious choices. Sometimes, how I've piled the discarded shapes to the side of where I'm working is closer to the unpremeditated and unpredictable elements I'm looking for than the piece I'm making.

Of all the remarkable things in ceramics, the explosion of a piece may be the most shocking. Exploded parts erupt, get turned upside down and back to front—everything is all mixed up, just barely resembling itself. This event can be as exciting as it is disappointing. A broken shard can be a more potent idea of the object than the object itself and a reminder of how elusive the chase is to find and identify the elements that excite. Any one piece out of context may reveal the work in a new way. The blown up work opened the possibility that pattern/order didn't have to rely on a formal organization. My thinking is to have pattern where no pattern was intended, rhythmic organization not by repetition, but by accumulation.

The nature of clay changes so profoundly in the course of working with it, from this soft brown muck, to a hard and perhaps shiny and usable thing—a real thing in the real world. I want the things I make, even though invented, to be as real and as believable as any other familiar object in the everyday. —JQ

Annabeth Rosen has held the Robert Arneson Endowed Chair at the University of California, Davis, since 1997.

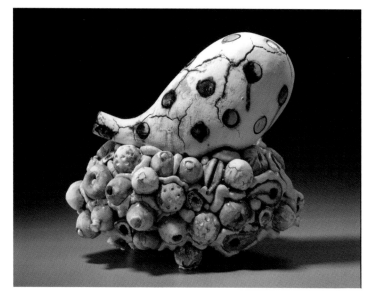

Selected Exhibitions: 2007—The Good the Bad and the Ugly, New Langton Arts, San Francisco, CA. 2006—Solo Show, Fleisher-Ollman Gallery, Philadelphia; Cruder, Hoffman Gallery, Lewis and Clark College, Portland, OR. 2005—Conjunction, The Schein-Joseph Museum of Ceramic Art, NYS College of Ceramic Art, Alfred University, Alfred, NY. NCECA International Exhibition Series: Taipei County Yingge Ceramics Museum, Taipei, Taiwan. STRATA, Skulpturens Hus, Stockholm, Sweden. Cranbrook to Lancaster and Back, Network Gallery, Cranbrook Museum of Art, Bloomfield Hills, MI. 2004—Standing Room Only, The 60th Scripps Ceramic Annual, Ruth Chandler Williamson Gallery, Claremont, CA. because the earth is 1/3 dirt, Boulder University Museum, Boulder, CO. Bay Area Ceramic Sculptors: Second Generation, The Daum Museum, Sedalia, MO. 2003—Solo Show, Nancy Margolis Gallery, New York, NY. Now & Now, Second World Ceramic Biennial, Icheon World Ceramic Center, Icheon, South Korea. Awards: Chancellors Fellowship 2000, Pew Fellowship 1992, National Endowment for the Arts 1979, 1986.

Annabeth Rosen, Untitled, (#30), 2006, glazed ceramic, 14.5 x 15.5 x 9.5 inches. Collection of the Bankeses, Philadelphia.

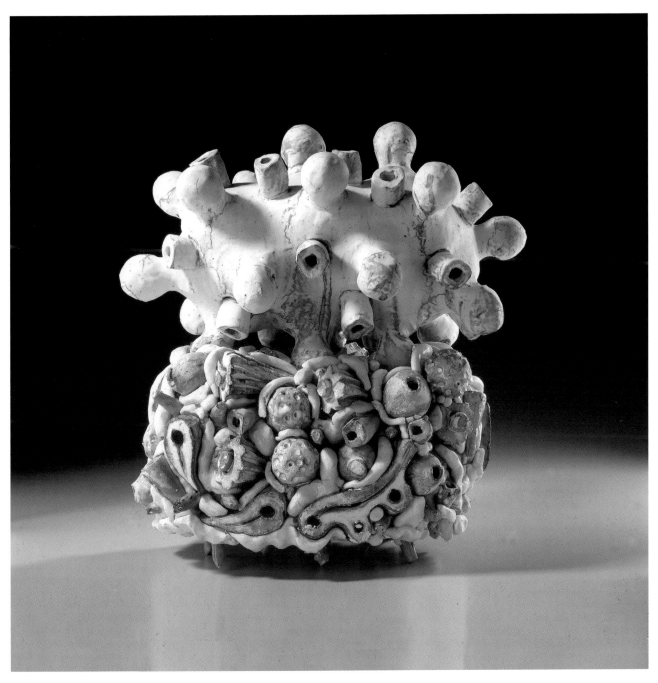

Annabeth Rosen, *Untitled #47* (Glacé), 2006, glazed ceramic, 17 x 15 x 11.5 inches.

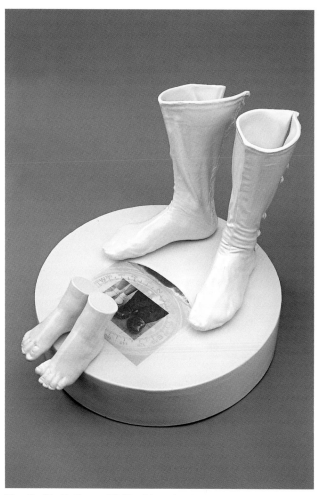

Nan Smith, *Pathway*, 2005, airbrushed and glazed earthenware with ceramic photo decal, 15.75 x 18 x 21 inches. Photo credit: Cheuvront Studios, Gainesville, Florida.

Figurative sculptures set within tableaux reflect my search for serenity and the quiet moments when this inner state becomes apparent. Sculpting the human body and placing it within a context permits me to explore consciousness by mirroring it outwardly. It also reflects my belief in the universal connectedness of our inner and outer worlds. As a sculptor my intent is to convey a sense of the psychology of intuitive nature as a female attribute. The temporal quality of human existence is an underlying theme implicit in the choice of clay as a sculptural material. Ethereal and white, reflecting the porcelain figurine and statuary traditions, the sculptures are idealized personifications. Refined and detailed they incorporate ornament, nostalgic imagery and still life objects to indicate the poetry and romance of a time past. Shrouded adult feet are apparitions which guide a child. The sculptures frame time and memory within a vignette; the salient moment conveyed in the bust; the tilt of its head, a gesture of a hand or in its facial expression. The body is envisioned alongside sepia toned photo decal images. The photographs function as symbols to expand the narrative and the feeling of nostalgia. The sculptures are intimate and contemplative; they picture memory and indicate a sense of its timelessness. —NS

Nan Smith is a Professor of Art at the University of Florida in Gainesville.

Funding for Nan Smith's sculpture was provided by the University of Florida Office of Research and Graduate Programs through the Fine Arts Scholarship Enhancement Award Fund.

Selected Exhibitions: 2007—*Form and Imagination: Women Ceramic Sculptors*, The American Museum of Ceramic Art, Pomona, CA. *The Narrative Figure in Clay and Paper*, Ellipse Art Center Gallery, Arlington, VA. *Beyond Mimesis—Contemporary Realism*, The Stecker-Nelson Gallery, Manhattan, KS. *2007 NCECA Clay National Biennial Exhibition*, The Kentucky Museum of Art and Craft, Louisville. 2006—*Pygmalion's Gaze Reimagined: The Figure in Contemporary Ceramics*, The Creative Alliance Gallery, Baltimore. 2004—*Nan Smith at RAWSPACE*, Watershed Center for Ceramic Arts at SOFA, Chicago. 2003—*21st Century Ceramics in the United States and Canada*, Canzani Center Gallery, Columbus College of Art and Design, Columbus, OH. 2001—*Taking Measure: American Ceramic Art at the New Millenium*. World Ceramic Exposition, Yeoju Korea.

Awards: 2000—University of Florida Research Foundation Professor. 1993—National Endowment for the Arts Southeastern Regional Fellowship. 1998, 1991, 1980—Florida Individual Artists' Fellowships.

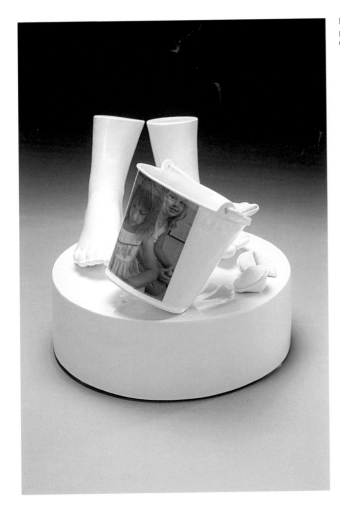

Nan Smith, *Serendipity*, 2006, glazed earthenware, ceramic photo decal, 11 x 12 x 13 inches. Photo credit: Cheuvront Studios, Gainesville, Florida.

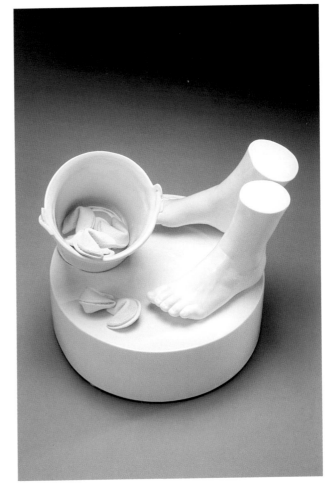

Serendipity, alternate view.

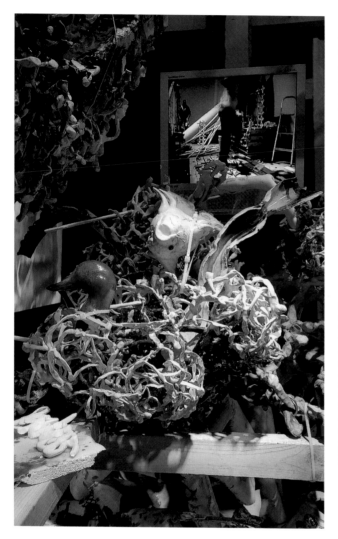

The work demands that I negotiate my presence before it, around it, under it, through it. The site looms above and veers past, willing me to compromise, to give ground. Overbearing and precarious, its appetites mirror my own. I roll and pinch the thing into place; I collect and lay offerings at its feet. This architecture melts and leans; it hoards objects in its folds. It lurches and dares you to approach it, it tears cloth and flesh, and it collapses with the brush of a hand. What propels the desire to make and compulsively make? Is this how I reassure myself, prove that I am here? If a ton of clay is in the room, and over time it is transformed—behaving and misbehaving—because of me, is it through making that I perform identity and establish a presence? —LS

Linda Sormin is an Assistant Professor of Ceramics at Rhode Island School of Design in Providence, Rhode Island.

Selected Exhibitions & Awards: 2007—*Mobile Structures*, Mackensie Art Gallery, Regina, SK (traveled to: Surrey Art Gallery, Surrey, BC). 2006—*Ontario Craft Council Art Winners Exhibition*, The Guildshop, Toronto, ON. *Cheh-ea Siah*, Solo Exhibition, Stride Gallery, Calgary, AB. *Contemporary Canadian Ceramics*, Esplanade Art Gallery, Medicine Hat, AB. *White Gold*, Flow Gallery, London. *From the North: Canadian Ceramics Today*, The Clay Studio, Philadelphia. 2005—*Taipei NCECA Exhibition*, Taipei County Tingge Ceramics Museum, Taipei, Taiwan. *The Conative Object*, York Quay Gallery, Harbourfront Centre, Toronto, ON. *NCECA Clay National*, Baltimore. *School's Out!*, NCECA Conference, Baltimore. *30,000+*, Charles H. Scott Gallery, Emily Carr Institute, Vancouver, BC. 2004—*Languor*, Lohin-Geduld Gallery, New York. *Hot Clay*, Surrey Art Gallery, Surrey, BC. 2003—*Selections I*, Lohin-Geduld Gallery, New York.

[*above*] Linda Sormin, Detail from *Roaming Tales*, 2007, ceramic and mixed media installation, Surrey Art Gallery TechLab. Photo credit: Scott Massey. [*right*] Linda Sormin, View from behind, *Roaming Tales*, 2007, ceramic and mixed media installation, Surrey Art Gallery TechLab. Photo credit: Scott Massey.

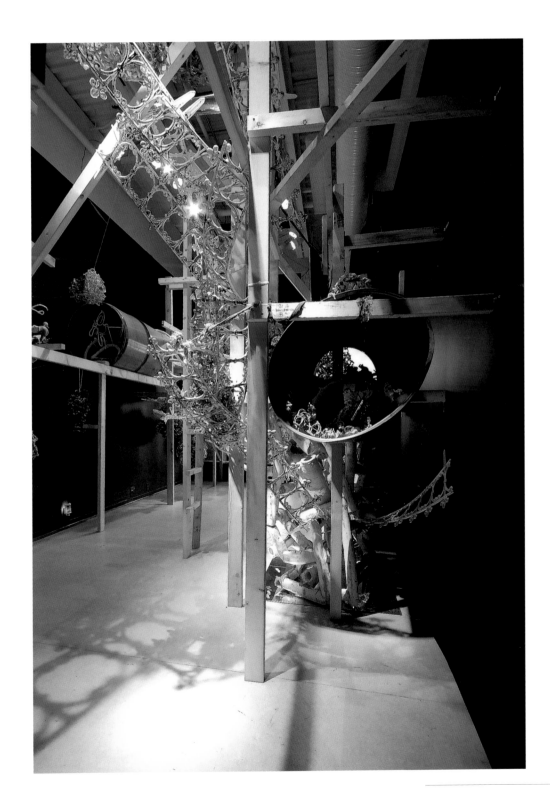

The act of "play" can involve the use or manipulation of toys or objects together with conscious or unconscious "scripting" and narration to create a new, temporary and satisfying reality. In play it is common to rename and reassign familiar symbols and objects to fit the script.

In Tennessee Williams' play "The Glass Menagerie," for example, we see Laura transcend her physical and emotional disabilities through play with her menagerie of glass animals; in her play, and in the moment of her play, she creates a script superior to her own reality.

My finished collections are housed within objects that themselves reference lost, abandoned and imagined "play" sessions and memories. In my finished pieces, these heavily used play objects, comprised mostly of discarded and abandoned toys from the 1950's, such as rusted strollers, carriages, wagons and dolls' trunks, have served to contain and "house" collections of representational glazed animals.

In my studio, this process of play is repeated by producing hundreds and hundreds of slipcast, polychromatic animals. Playing, arranging and recording my variations on reality preserves this moment in each finished work. —WW

Wendy Walgate maintains a studio in the historical Distillery District of Toronto, and is a member of the Royal Canadian Society of Artists.

Selected Exhibitions & Awards: 2007—*Wendy Walgate & Carrie Ann Parks*, Pewabic Potter, Detroit. 2006—*Telling Tales*, Dashwood Gallery, Calgary, AB. *Vivid: Rebekah Havey & Wendy Walgate*, Northern Clay Center, Minneapolis, MN. *From the North: Canadian Ceramics Today*, The Clay Studio, Philadelphia. *An Extravagance of Salt & Pepper*, Baltimore Clayworks, Baltimore. 2005—Awarded membership in Royal Canadian Society of Artists. *Juried Exhibition*, Honorable Mention, Gallery International, Baltimore. *Convergence Juried Exhibition*, Dr. Allan Pollack Award, Tom Thomson Gallery, Owen Sound, ON.

[*above*] Wendy Walgate, *Hannibal Bear High Chair*, 2007, white earthenware, slipcast and glazed, metal toy high chair, 32 x 11 x 15 inches; [*left*] *Bye Baby Bunting Cradle*, 2007, white earthenware, slipcast and glazed, vintage wooden toy cradle, 19 x 18 x 9 inches; [*facing page*] *Five Litres: Avitus*, 2007, white earthenware, slipcast, glazed, glass lab beaker, metal tags, 12 x 12 x 8 inches. Photo credit: John Goldstein.

In my sculptural practice I am interested in the dichotomy between the absolute and the abstract in visual and cognitive recognition and how these perceptions can be distorted. I am challenged to incorporate meaning through beauty that is both conscious and subconscious.

The work has developed through the process of being, living and interacting. It is a materialized reflection of my experience. In the work, I draw on my own actions and reactions to forge a dialogue between controlled and uncontrolled situations. The work is fueled by an obsession to learn and to understand my interests and behaviors. It is rooted in visual perception and explores the use of objects, surfaces and environments as specific forms and symbols for thought. Through the work, I seek to make sense of a puzzle in my mind, selecting the appropriate pieces and logically laying them out. The intrigue is in the manner in which an object is visualized and conceptualized —how it is transferred from the denotative to the connotative. —JY

Julie York is an Assistant Professor at Emily Carr Institute of Art & Design in Vancouver, British Columbia.

Selected Fellowships and Awards: 2007—Pew Fellowship, Pew Fellowship in the Arts. 2005—Independence Foundation Grant. 2004—Creative Production Grant, Canada Council for the Arts. 2003—The Evelyn Shapiro Foundation Fellowship at The Clay Studio. Selected Solo Exhibitions: 2007—Perimeter Gallery, Chicago, 2006 SOFA Chicago, Chicago. 2005—Samuel S. Fleisher Art Memorial, Philadelphia. 2004—Garth Clark Gallery, New York. 2003—The Clay Studio, Philadelphia. Selected Group Shows: 2007—*Aqua Art Miami*, represented by Pentimenti Gallery, Miami. *Flow Miami Invitational Art Fair*, represented by Mulry Fine Arts, Miami. *Unadorned*, Santa Fe Clay, Santa Fe. 2006—*One Part Clay Avant-garde & Mixed Media*, Dean Project, Garth Clark, New York. *Iner_Logic*, The Leonard Pearlstein Gallery, Philadelphia. 2005—*3,000 +*, Emily Carr Institute of Art & Design, Vancouver. *White on White*, Wayne State University, Detroit.

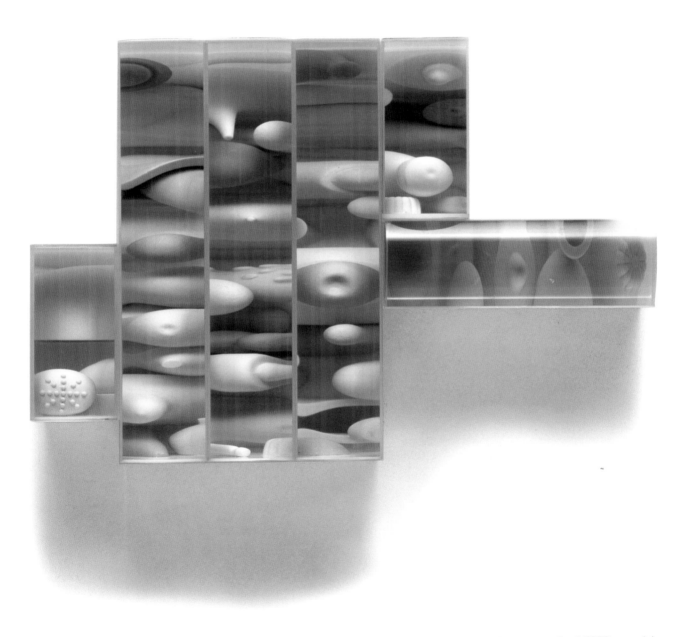

[*facing page*] Julie York, *peep series*, 2007, porcelain, glass, plastic, 5 inch diameter each; [*above*] *c-space series* 1, 2006, porcelain, glass, plastic.

Holly Hanessian, Detail of *ALL*, 2007, wall installation, paint and porcelain.

FLORIDA STATE UNIVERSITY

T. K. Wetherell, President

Lawrence G. Abele, Provost & VP for Academic Affairs

Sally McRorie, Dean, College of Visual Arts, Theatre & Dance

MUSEUM STEERING COMMITTEE

Jack Freiberg, Assoc. Dean, CVAT&D

Richard K. Emmerson,Chair, Art History Department

Cameron Jackson, Director, School of Theatre

Lynn Hogan, Assoc. Dean, CVAT&D

Allys Palladino-Craig, Director, Museum of Fine Arts

Patty Phillips, Russell Sandifer, Co-Chairs, Dance Department

Marcia Rosal, Chair, Art Education Department

Joe Sanders, Chair, Art Department

Eric Wiedegreen, Chair Interior Design Department

MUSEUM OF FINE ARTS STAFF

Allys Palladino-Craig, Director

Viki D. Thompson Wylder, Curator of Education

Jean D. Young, Collections Registrar / Fiscal Officer

Teri Yoo, Communications Officer

Wayne Vonada, Senior Preparator

Stephanie Tessin, Art in State Buildings / Special Projects

Lori Neuenfeldt and Alison L. Moore, Events

Becki Rutta, Sang Sungeon, Katie Reinhardt
Graduate Assistants

Camille Davie, Jackie Dougherty, and Samantha Ogden,
2007-2008 Interns

Alyse Sedley, Volunteer Coordinator

Kelly Paul, Ashley Hickman, Assistant Volunteer Coordinators

VOLUNTEERS:

Maxie Balthrop • Margot Brody • Malcolm Craig •
Katherine Farley • Julie Guyot • Heidi Hargadon •
Ashley Jehle • Austen Kane • Kara Leffler • John Luthin
• Ben Peterson • Whitney Russell • Elizabeth Shanks
• Rachel Thornton • Sara Turner • Tom Wylder

MUSEUM OF FINE ARTS
FLORIDA STATE UNIVERSITY
COLLEGE OF VISUAL ARTS, THEATRE & DANCE
TALLAHASSEE, FLORIDA 32306-1140
ISBN 1-889282-20-0

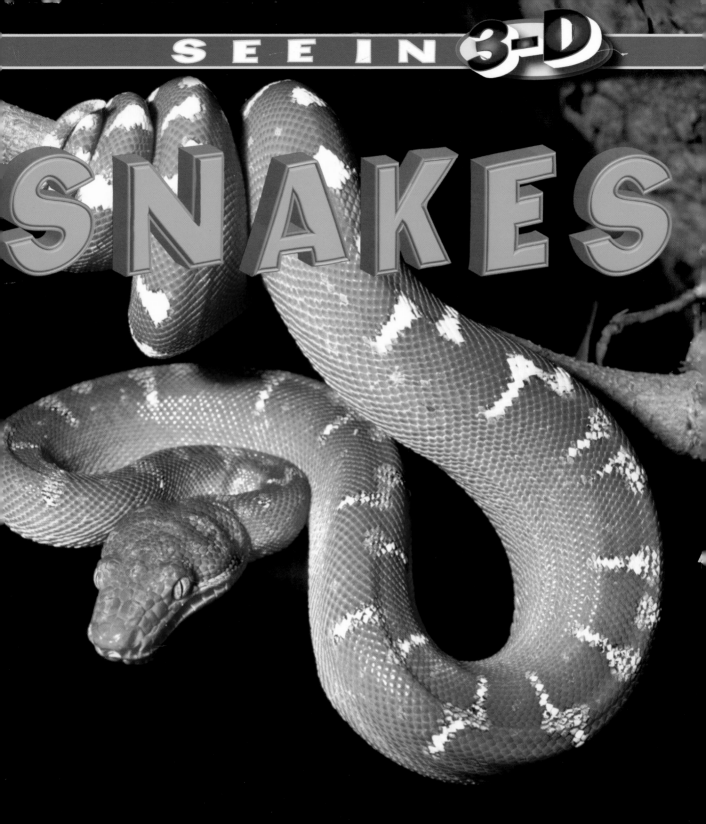

SEE IN 3-D

SNAKES

SEYMOUR SIMON

SCHOLASTIC

SEE IN 3-D

SNAKES

SEYMOUR SIMON

SCHOLASTIC INC.
New York Toronto London Auckland Sydney
Mexico City New Delhi Hong Kong Buenos Aires

To Michael and Jeremy,

second and third generation of Simon Snake Lovers.

ACKNOWLEDGMENTS

Special thanks to Ron Labbe of Studio 3D for his expertise and 3D photo conversions. Thanks also to Alison Kolani for her skillful copyediting. The author is grateful to David Reuther and Ellen Friedman for their editorial and design suggestions, as well as their enthusiasm for this project. Also, many thanks to Gina Shaw and Jenne Abramowitz at Scholastic Inc. for their generous help and support.

PHOTO CREDITS

Front cover: © Jany Sauvanet/Photo Researchers, Inc.; back cover and pages 8–9: © Michael Lustbader/Photo Researchers, Inc.; pages 1, 3, 4–5, 7, 10–11, 13, 14, 15, 20–21, 23, and 24: © Robert Bloomberg; page 6: © Linda Lewis/Frank Lane Picture Agency/CORBIS; pages 16–17: © Ed. George/Getty Images; pages 18–19: © Joe McDonald/CORBIS.

Book design: Ellen Friedman

ISBN-13: 978-0-439-86651-4
ISBN-10: 0-439-86651-0

12 11 10 9 8 7 6 5 4 3 2 1 7 8 9 10 11 12/0

Printed in the U.S.A.
First Printing, November 2007

There are about 2,900 different kinds of snakes, and they come in all shapes and sizes. From small garter snakes, which may be found in nearby fields, parks, and backyards, to giant anacondas, which live in the tropical rain forests of South America, snakes live in every part of the world except for Ireland, Iceland, New Zealand, the Arctic, and Antarctica.

Snakes are reptiles. They are related to lizards, turtles, and crocodiles. Reptiles have scaly skin and are cold-blooded. But that doesn't mean that their blood is cold. Cold-blooded animals depend on sunlight, warm air, warm water, or sun-warmed surfaces for body heat. Warm-blooded mammals and birds can make heat inside their bodies.

Snakes need warmth to be active. When their surroundings are cold, they become still. Because of that, many snakes live in tropical climates. In places where it gets cold in the winter, snakes are active only during the warmer seasons. During the winter, snakes hibernate together in large numbers in rocks, burrows, or other underground dens.

5

Snakes don't feel slimy. Their scales are really thick, hard bits of skin. Snakes have three layers of skin. The inner layer is the thickest and gives the snake its coloring. Neutral colors can help to camouflage a snake from predators, and bright, bold colors may signal enemies to stay away.

The middle layer is also thick and tough; it protects the snake against rough ground and rocks. This layer is made up of thousands of interlocking scales that form a coat of armor that is still very flexible.

The outer layer of a snake's skin offers extra protection. As a snake grows larger, it sheds this third layer to make room for its growing size. This forms the "snake skin" you sometimes find outside or see on display. Young, rapidly growing snakes may shed their skin six times a year.

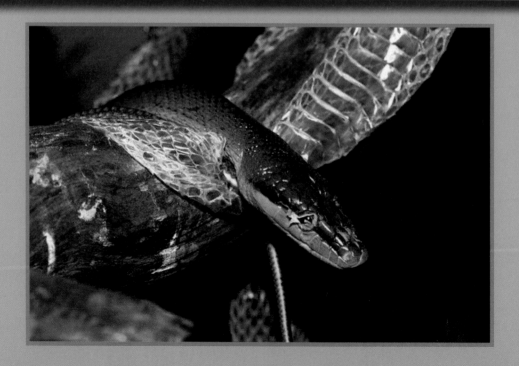

Humans have thirty-three small bones, called vertebrae, that make up their backbones. Some long snakes have as many as 500 vertebrae. All these bones allow snakes to move their bodies back and forth easily. Snakes can't walk, but they can move across the ground in different ways.

The most common movement is called *serpentine* motion. Snakes use their muscles to make a series of loops with their bodies. Each loop pushes back against the surface the snake is lying on. This propels the snake forward. Most snakes move more slowly than a person can run.

Some kinds of rattlesnakes and vipers use *sidewinding* to move across loose sand. Sidewinders move two or three loops of their bodies at one time. The tracks of a sidewinder look like steps on a slanted ladder.

Most snakes have eyes that are well developed and can sense the slightest movement around them. Snakes that are active at night usually have large eyes that can gather more light. There is no evidence that snakes see colors the way we do.

A snake's ears are inside its head, so there are no ear openings on the outside. Snakes don't hear sounds in the air very well, but they can sense tiny ground vibrations made by mice and other small animals. The vibrations help them locate these animals, which they hunt for food.

Snakes also have an excellent sense of smell. They smell with their tongues as well as their noses. A hunting snake constantly flicks out its moist tongue, picking up tiny particles of odors from the air or ground. The odors are "tasted" by a special sensory organ in the back of the snake's mouth.

Cobras, mambas, coral snakes, the taipan, and the death adder make up a family of poisonous or venomous snakes called *elapids*. Most of these snakes have hollow fangs that are always erect and ready to inject venom.

The king cobra is the longest venomous snake, sometimes reaching lengths of over 15 feet. A cobra can raise its head off the ground and spread its hood by using the ribs in its neck.

Two of the deadliest snakes in the world live in Australia—the taipan and the death adder. A bite from either one can result in death within a few hours unless promptly treated. India has the largest number of fatal snakebites—between 10,000 and 20,000 deaths each year.

FUN FACTS

"Spitting" cobras can spray their venom when they are defending themselves against an enemy.

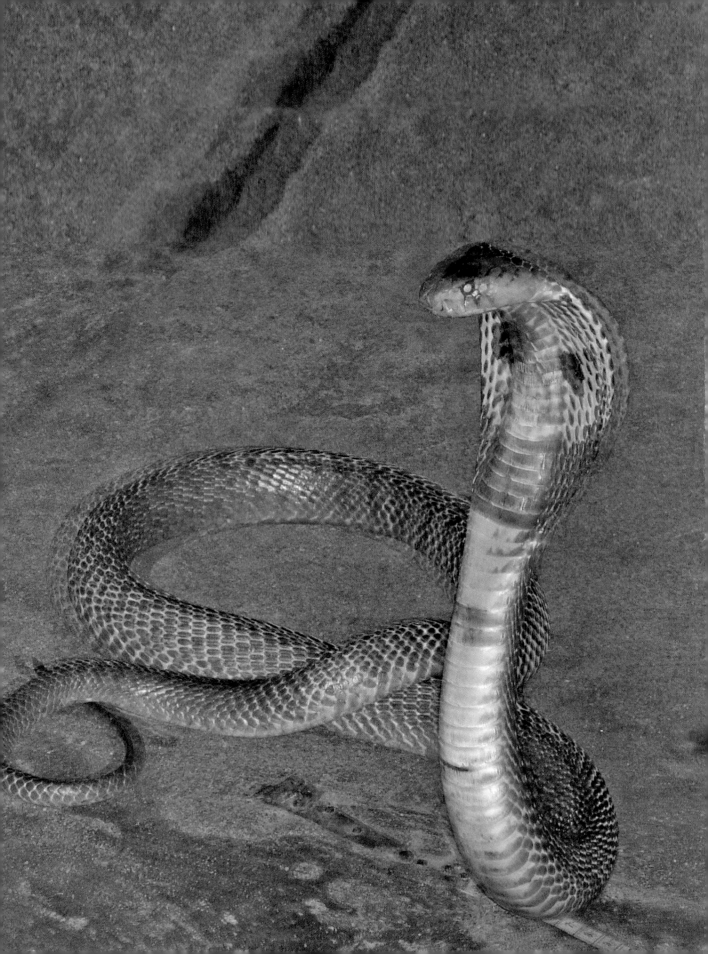

Another large family of venomous snakes is the viper
family. Vipers have hinged fangs that fold back in their
mouths. When a viper is about to bite, its fangs move up
and forward and venom flows through them. Vipers such
as the puff adder, the Gaboon viper, and the European adder
mostly live in Africa, but a few types are also found in Europe
and Asia.

Pit vipers—such as rattlesnakes, copperheads, and water moccasins—live in the Americas and parts of Asia. These vipers have small, heat-sensing openings, called pits, on their heads. Using these pits, a rattlesnake can find warm-bodied prey even in complete darkness.

Rattlesnakes are the only snakes that have scales at the tip of their tails, which form rattles. When a rattler shakes its tail, the rattles hit each other and make a buzzing sound, which frightens away enemies.

Giant snakes are the longest land animals living today. Some boa constrictors can grow to be as long as a car. An African python can even grow as long as a station wagon. The longest snakes of all, the anaconda and the reticulated python, can be as long as a school bus.

Except for the king cobra, all giant snakes are either boas or pythons. Both types look and act almost the same. One difference is that boas bear live young, while pythons lay eggs. Another difference is that boas mostly live in South America and Central America, while pythons live in India, Southeast Asia, and Africa.

FUN FACTS

Anacondas, a type of boa constrictor, can be nearly 30 feet long and a foot in diameter; they may weigh over 500 pounds.

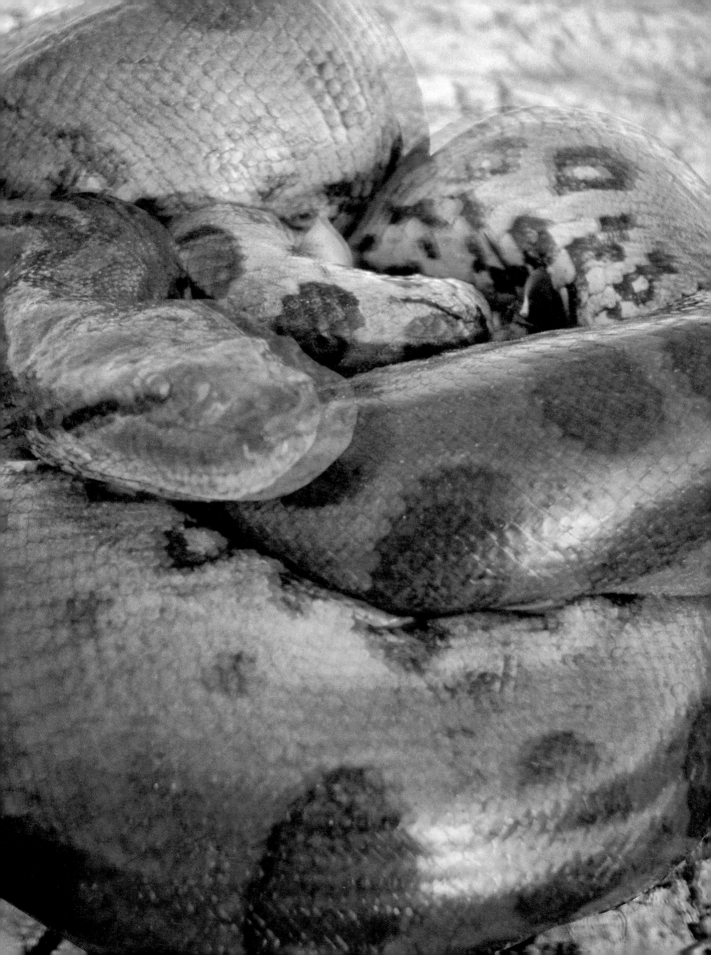

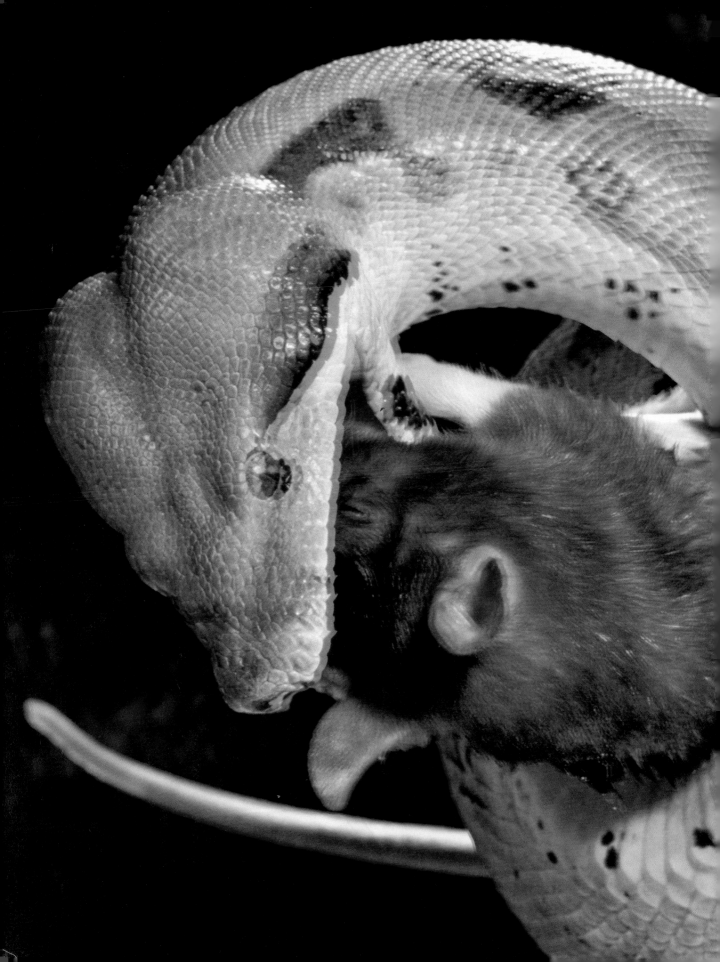

All snakes prey on animals. Some snakes search and hunt for their prey. Others sit and wait for food to come close to them. Snakes such as cobras and rattlesnakes use venom to kill. Other snakes, like boas and pythons, are constrictors. They coil their flexible bodies around their prey and keep tightening the coils. Constrictor snakes don't actually crush their prey, though. Instead, they squeeze the animal's chest until it stops breathing.

Snakes don't chew their food. A snake bites an animal to hold on to it. Once the prey is in its mouth, the snake's jaws move slowly over the body until the animal is swallowed whole. A snake's jaw is double-hinged, so it can open its mouth wide enough to swallow prey even larger than its own head.

Small snakes eat insects, lizards, mice and other small mammals, birds, bird eggs, fish, frogs, salamanders, and even other snakes. Large snakes feed on bigger animals such as rabbits, monkeys, pigs, deer, and domestic sheep and goats.

FUN FACTS

It may take hours for a snake to swallow a big animal and weeks or even months to digest that meal.

Most kinds of snakes lay eggs in late spring or early summer. They lay them in holes in the ground, in rotting logs, or in abandoned animal burrows. Depending on the type of snake, a clutch of eggs can range from a single egg to more than a hundred eggs. Most mothers leave their eggs to hatch on their own. Only a few types of snakes, such as some pythons, stay with their eggs until they hatch.

Garter snakes, water snakes, pit vipers, and boas don't lay eggs. Instead, they keep the snake embryos inside their bodies until they are fully developed. Then they bear perfectly formed live young. Most young snakes are quickly left on their own and are not protected by their mothers.

Venomous snakes are more deadly than sharks, lions, tigers, and wolves put together. In fact, venomous snakes kill more people in a single year than sharks do in a hundred years.

But most snakes are harmless to people. They help us in many ways, particularly by preying on rats, mice, and other rodents that can cause diseases. It may be hard for most people to love snakes, but we can learn to appreciate what interesting animals they are.